D0549054

KATHY SHORR

SHOT

101 Survivors of Gun Violence in America

powerHouse Books

Brooklyn, NY

For my family and the family of survivors

PREFACE

We live in a society in which actions are divorced from consequences. The effects of violence become invisible, floating around as an abstraction, which enables people who support gun rights not to have to confront the consequences of their investment in a culture of violence. Your project challenges that perception.

—Henry Giroux
Professor for Scholarship in the Public Interest, McMaster University

SHOT is about "survivorhood." The 101 visual narratives represented here are heartbreaking, yet they bear witness to the perseverance of human spirit. The pain is evident in each scar and in each of the wounded. Remarkably, the survivors continue to move forward with strength, courage, and determination.

People ask why I chose to create the *SHOT* project. What was it that interested me in survivors of gun violence? There wasn't one specific reason; rather, it was a convergence of things that began with my own encounter with a gun during a home invasion years ago. Later as a high school teacher in an urban public school, I would often see teens wearing necklaces with laminated photographs of friends and family members killed by guns—victims who had become "folk" heroes in neighborhoods decimated by shootings. My thoughts focused on the others—the survivors of gun violence. Where were their tributes? Who thought of their trauma?

I wanted to give a human face to an issue that affects all Americans through documenting the injuries sustained by real people. At a time when we seem to talk *at* each other rather than *to* each other, we need to find ways the dialogue on gun safety can lead to a constructive resolution.

One of my most profound moments working on this project occurred when I photographed the late Bill Badger, who was shot in 2011. Bill was both a gun owner and a man who fought for reasonable change regarding gun ownership and gun laws. Speaking with him helped me to realize that bringing about that change required men and women to come together in support of sensible gun laws that do not infringe upon the rights of responsible individuals to own a gun.

SHOT survivors include individuals from an array of backgrounds: Army sergeant, blues singer, bank vice president, councilman, Episcopal bishop, bus driver, police officer, ex-prostitute, community activist, psychologist, Army colonel, ex-gang member, motivational speaker, assistant principal, teacher, corrections officer, mouth painter, lawyer, doctoral candidate, retired firefighter, small business owner, office worker, social worker, college professor, Air Force active duty, hotel worker, Little League coach, family advocate, accountant, rock musician. *SHOT* includes college students, high school students, and even a third grader, and many participants are under the age of 20.

For *SHOT*, I traveled around the United States from late 2013 to the end of 2015 and photographed survivors of shootings. *SHOT* embodies all races and many ethnicities, with a range of ages from 8 to 80. Both high- and low-profile incidents are represented. Many gun owners and an NRA member, who actually survived because of his licensed gun, are represented in the project.

Most of the survivors were photographed where they were shot. These locations are familiar to everyone, as bad things often happen in "normal" places. Many were shot inside of their cars or in their homes, and others at the gym, church, shopping center, movie theater, or on the street in their neighborhood, and on public transportation—random or intentional, all are part of the story of gun violence.

A joint research study by Harvard and Duke universities found that an estimated 9 percent of adult Americans with impulsive anger issues either own or have access to a gun. This study discloses the dangers that it poses to each and every community.*

I am extremely grateful to all of the survivors who generously agreed to participate in this project, and who did so in the hope that their stories might help to prevent such trauma for others.

It is my hope that *SHOT* will act as a catalyst for people to address the life and death issues of gun violence and responsibility in a less polarized environment.

Kathy Shorr

* http://corporate.dukemedicine.org/news_and_publications/news_office/news/nearly-1-in-10-adults-has-impulsive-anger-issues-and-access-to-guns

FOREWORD

Mister Goodman invited him out and modified him with a bullet.

—Mark Twain

For some very weird reason, analogies have been drawn between what a camera does and what guns do. A photograph is often referred to as a "shot" and a session of shots might be called a "shoot." Now, a camera does not shoot, while a gun does, but both instruments are aimed toward specific subjects or targets in view. How different, though, the intent—and the result—when the targets are human beings. In the one instance, images of our fellow creatures are retained, which aids memory of their presence, and in the other, the goal is to obliterate their lives, and therefore to erase that presence. Suppose we say that cameras and guns communicate things: the first device conveys social and personal news via pictures, and the second one delivers a small but murderous piece of metal. This book is a portfolio of photographic portraits of various individuals in the United States, 2013 through 2015, who survived being shot by a gun, and who agreed to tell an outsider something about it.

The creator of the book, Kathy Shorr, has taught photography in New York City public schools and colleges, and is known as a photographer concerned with imaging people in specific locales or situations. In earlier works, she depicted behavior in a limousine, which she drove, and in another, the life of homeless families in a shelter. Here, she reached out over horizons to people who had been very unpleasantly wounded by one or more bullets. From a passing car, a pedestrian was randomly shot. Or someone was peacefully at home when a slug smashed through the window. The newspapers are filled with stories like theirs—more topical, repetitive, and continuous than those that report larger events. In our increasingly incoherent and angered society, a wave of shootings has been energized by a climate of fear, emotional breakdowns, bigotry that outs itself, drug addiction, and a race to stockpile personal armaments. Each of these contagious abuses has added to a malaise now recognized as a national problem—and one becoming worse.

But I am getting ahead of necessary questions: What kind of portraiture does Kathy Shorr actually give us? And how does it contribute to awareness of its titular theme?

From its beginning, the practice of photography has been spurred on by portrait genres, which serve various functions. We have heard of mug shots and we know passport photos. Glamour pix are quite familiar, and so are birthday celebrants. And now we have to add selfies, generally taken with cameras in cell phones. Each of these categories has its bland conventions and visual formulae. For couples who want to illustrate their wedding vows, you can be sure their collection will include an image of two faces close together and smiling, in fact beaming. When the passage of time inflects the original, mundane occasion, however, portrait content might become sorrowful, and fall unofficially into a different file. Such is the effect of a smiling, healthy face, in the prime of life, which appears years later in an obituary column. Self-presentation is always vulnerable to the shifting dynamic of its own consciousness and the social predilections of viewers from outside communities. We have stakes in photographs as nuanced—and also fixed—evidence of life in earlier times. That is why the identity, membership, and manners of distinct groups help so much in reading portrait images. A viewer reckons with the decorum implied, even if the process is only notional and reductive.

Kathy Shorr's perspective is that of a street photographer, with an inherent interest in faces. Ordinarily, her impulse would be to catch some hint of a person's psychology, activated within the scenography of habitat. Where the subject lives and how he or she dresses or volunteers a stance, all that gives information about material possessions and social style. In this book, nevertheless, such information, while plentiful, is not backed up by any standardization in the photographer's approach. Really intimate close-ups contrast with distanced figures at suburban street corners. Individual portraits reveal some distinct variations in income levels, but none of them dominates the collective outlook of the whole. African Americans have a large role in these pages, but then so do Whites or Latinos from an array of geographical locales. And what is one to make of puckered scars, welts, or prosthetic aids, which speak of bodily injuries, whereas the overall accent is on faces?

On this point, Kathy Shorr's portrait campaign would almost seem to morph into a still-life project, that is, a framing of objects such as punctured limbs, necks, and torsos, similar in effect to forensic medical records. And yet they have a central place in the rhetorical atmosphere of the book, since they exhibit physical evidence that the subjects had been shot. One even has the sense that many of her sitters were quite willing to reveal that evidence. Their living wholeness had once been threatened, as we see, but it would be reaffirmed in other pictures.

Meanwhile, the heterogeneous character of the portraits deflects any idea that the photographer had in mind an internal order of representative figures, or stock types. The moment of the click comes to us as an outcome of a first meeting between two people on hospitable terms with each other. They had agreed to have their portrait taken at or near the scene of the crime. There are several such moments that hover in the shadow of a larger theme but do not exploit it. At the same time, the photographer's unpresuming stance makes for freshness of contact and transparency of effect. In the nighttime city portrait of Sahar Khoshakhlagh, red and white stripes from a fluorescent sign of the American flag race in from the right, as if to interrogate her worried elegance. Aisha Adams looks squarely at Kathy, but also a little obliquely, as a false eye has replaced the one she lost when she was attacked by a teenage acquaintance. To the left spreads an out of focus blur of lawn and trees, perhaps a mute suggestion of her injury's effect upon her sense of sight. I should also like to mention the splendid view of a mountainous landscape, the background for a few nearby ranch style homes and a tenebrous area, where a woman, almost unseen, sits in a wheelchair. LaDawn Prue had been dragged into a car by an ex-prisoner, where he shot her a couple of times (which left her with a paralyzed back). Finally, a husky police sergeant, Greg Meagher, stands in front of a small red building absurdly decorated at foot level with little cartooned flames. He had been shot in the face at a drug bust and now faces the camera in dark sunglasses.

Without text and captions, one might be hard-pressed to know what these portrait sitters have in common. Their affiliations go in different directions, but in the aggregate, what they share is an excruciating experience. Let George Orwell, who had been wounded years before, describe the awful sensation:

> *The whole experience of being hit by a bullet is very interesting…. Roughly speaking, it was the sensation of being at the centre of an explosion. There seemed to be…a blinding flash of light all around me, and I felt a tremendous shock—no pain, only a violent shock, such as you get from an electric terminal; with a sense of utter weakness, a feeling of being stricken and shriveled up to nothing.* [1]

Orwell had been a fighter in a war zone, whereas the victims here were leading their own civilian lives, when a kind of war entered. They had every right to be allowed to carry on their doings in peace, and they were denied that right. The transgressive, malignant moment could not be visualized, only retold by victims in their own words. Of course, speech is an instrument of memory that can recount a hazard of the past. Those who have gone through that hazard are here united inadvertently and temporarily by the convergent stories they can tell. But this book goes further by showing—through photographs—that these victims

are still alive, despite their ordeal. The fact that they did not have to pay a fatal price for what happened to them does not lessen the wrong they suffered. The crisis of gun homicide, of course, still exists; indeed, it has gone viral. In its own way, this book testifies to the damage shootings have caused—vividly, and authoritatively—because the voices gathered speak from an undeniable personal knowledge. As you turn the pages, a dialogue springs up—between pride and sadness, and also, between somber thought and radiant color.

Max Kozloff

1. George Orwell, *The Complete Works of George Orwell,* ed. Peter Davison, London, Penguin, 2001 pp. 131-32

You are the first woman that I ever took to the location where it happened that terrible night. Going back there sent shivers down my back; I looked brave but, hey, it was all so real. The double-barrel sawed-off shotgun being fired into my abdomen and me trying to hold my internal organs inside my belly while the blood flowed like the Nile River.

Albert Randle

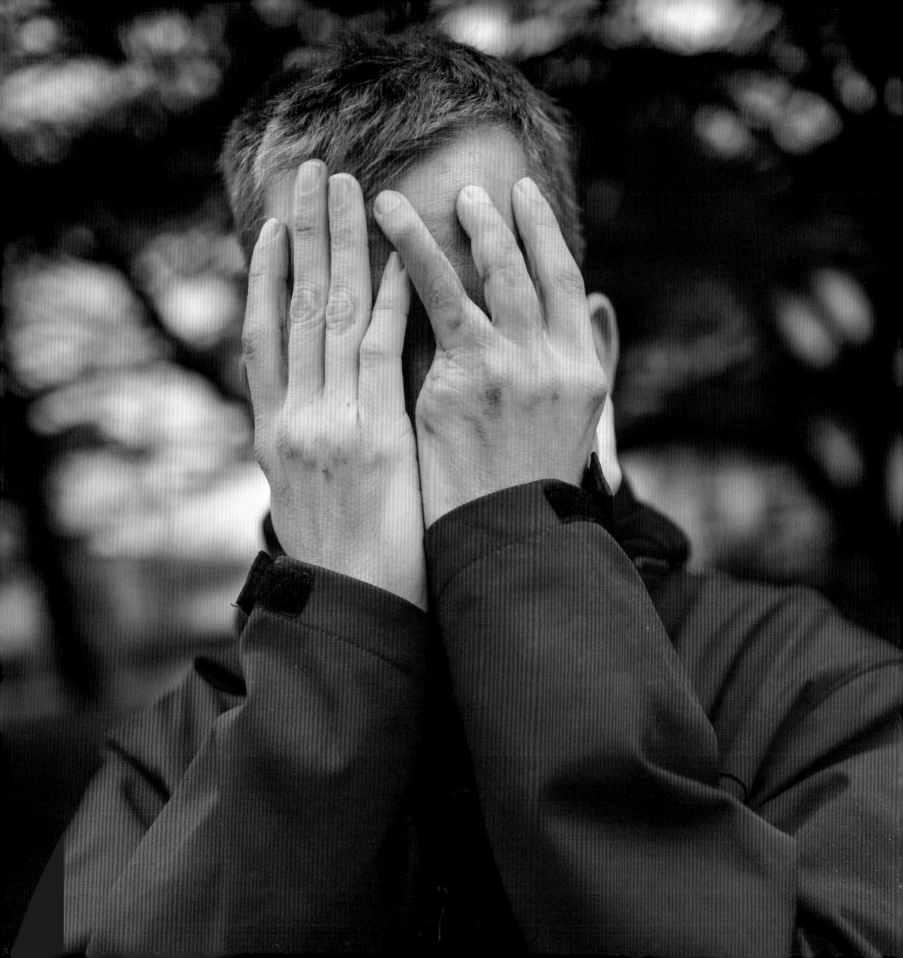

SHOT

101 Survivors of Gun Violence in America

It now seems clear that two officers, though surrounded by crowds of innocent bystanders like myself, fired repeatedly at a man who was exhibiting unstable behavior.
Sahar Khoshakhlagh

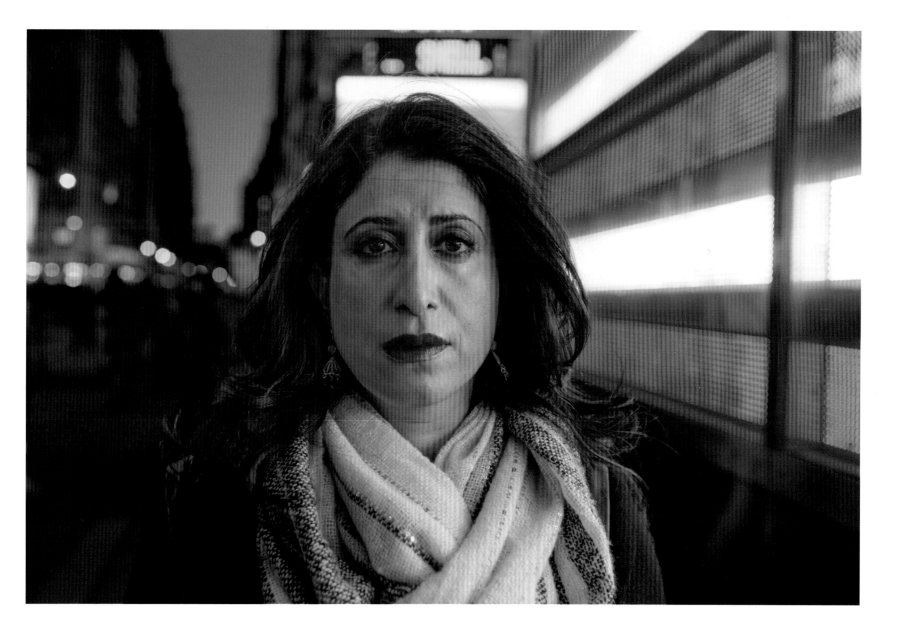

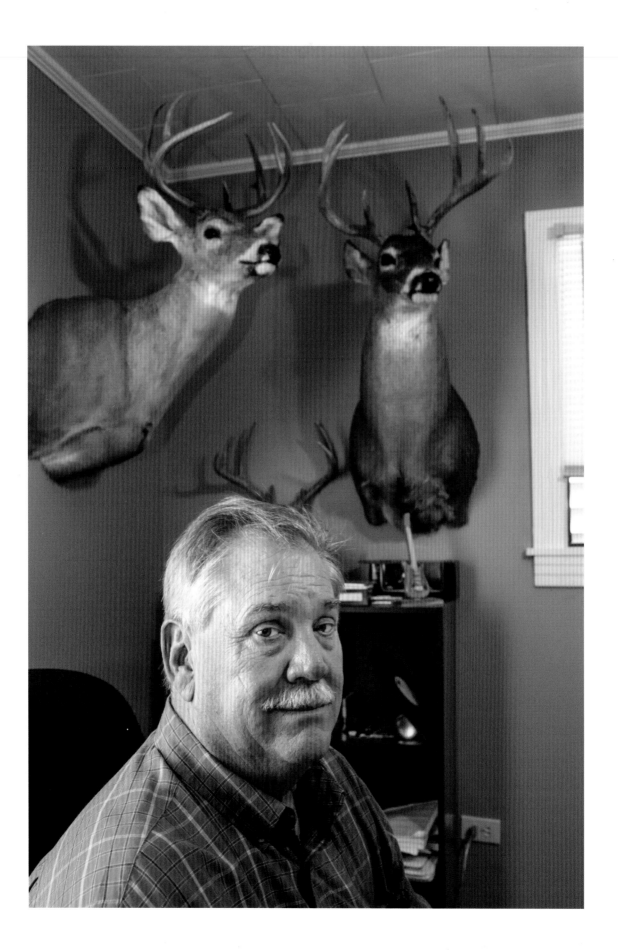

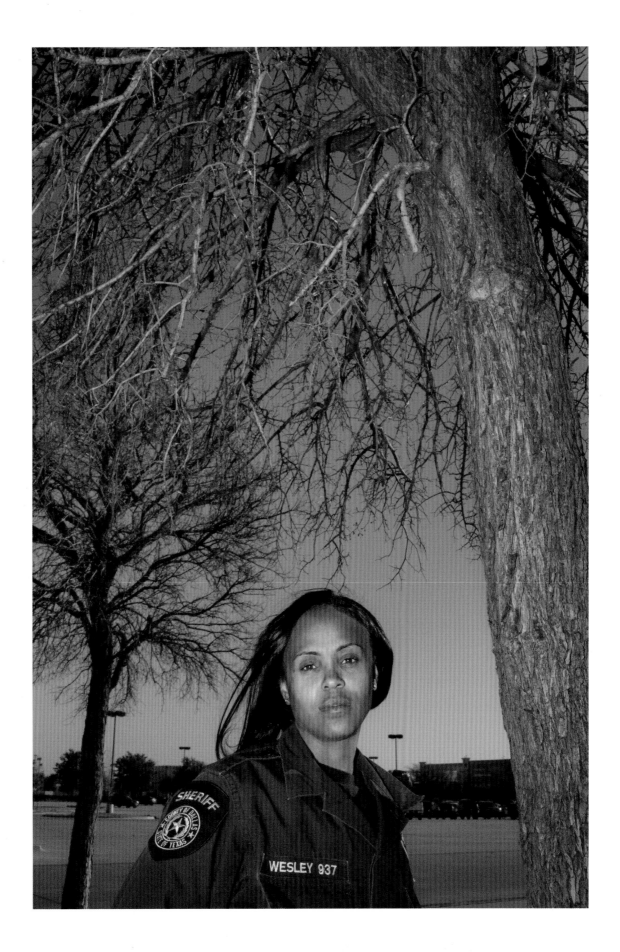

I knew I had been shot. I felt the explosion in my back.
My sister sitting next to me pressed on my chest hard enough to suffocate me.
I said I'm going now. I'm going… My head felt heavy and the world was turning gray.
She said, "No!! You aren't going anywhere!!!"
Mary Jo McLaine

While in a car on the way to help my mother with her janitorial work, I was struck by a
stray bullet that exploded the right side of my face. I remember picking up chunks of
cheek, meat, bone, teeth, and blood off of my chest and thighs as I sat in the car that we
were shot in. I nearly died that night.
Caheri Gutierrez

I lived because of my family, training, and fellow officers, but I was changed forever.
Sergeant Greg Meagher

To demonstrate how this is a dramatic change in how I lived my life before, I was
a firefighter both professionally and for the volunteers. Also I was a member of the
Montana Air National Guard/Air Force for 23 years. During my career I was activated
for Desert Storm. With this background I was subject to a lot of stressful situations,
physically and mentally. I never have experienced such terror before, as the terror
resulting from the crimes that Diana Arnold inflicted upon me.
Hugh Dave McDunn

I was shot three and a half years ago today and I can still feel the effects of that day. I had a stroke that was caused by the shooting that affected my balance, hearing, and vision. My far vision will be blurred the rest of my life. But more importantly, I can never get the image of that day out of my head.
Colonel Bill Badger

So I got on my knees as he stood over me, I closed my eyes and I counted. One…two… three. I believed he would run. Instead, he pulled the trigger. I remember what it felt like. I remember my body flying backward and slamming into the ground.
Sara Cusimano

I was born and raised in the Aliso Village housing projects; I grew up with a step-dad, my mom on welfare… I had no father figure, all my uncles are from the same gang I'm from except one—he ended up getting into my enemies' gang.
Gus Mojica

Never in my wildest dreams did I think I would be shot with a gun. Never did I think I would ever end up in a wheelchair because of it. I had lived my entire life thinking that was the type of thing that happened to other people in other parts of the country, or to people in books or TV. Until one day the unthinkable happened… and it didn't happen to somebody else, it happened to me.
Mariam Pare

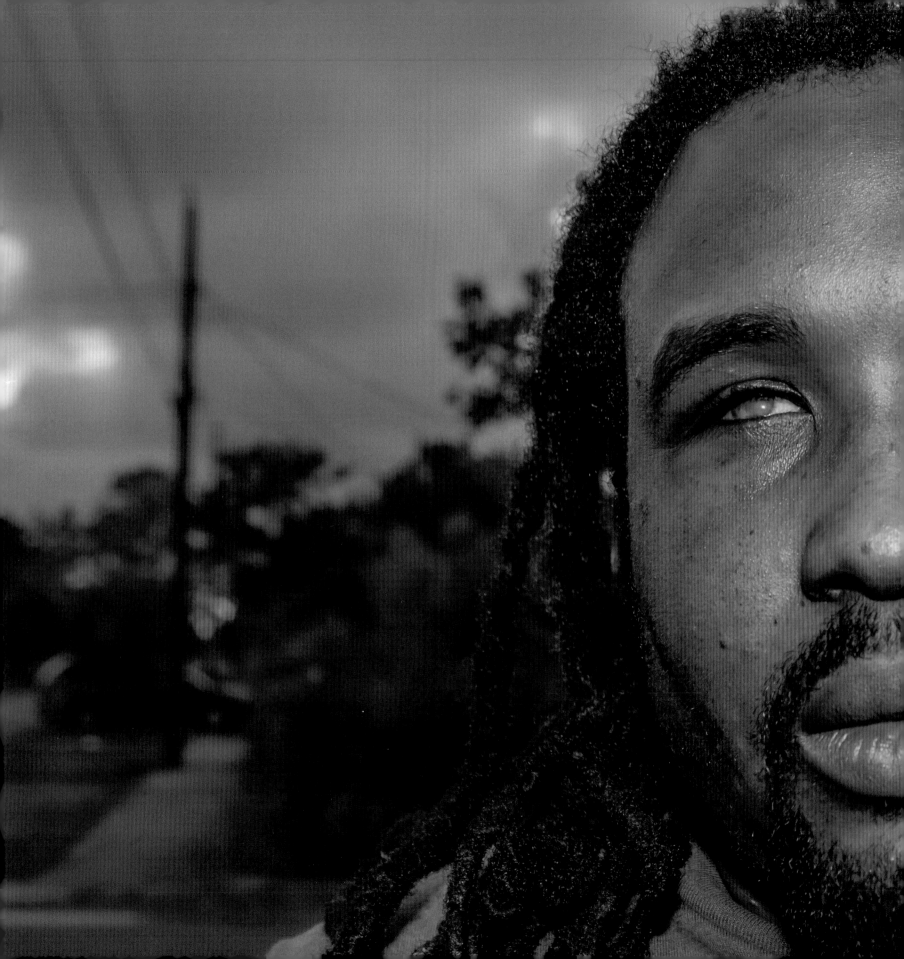

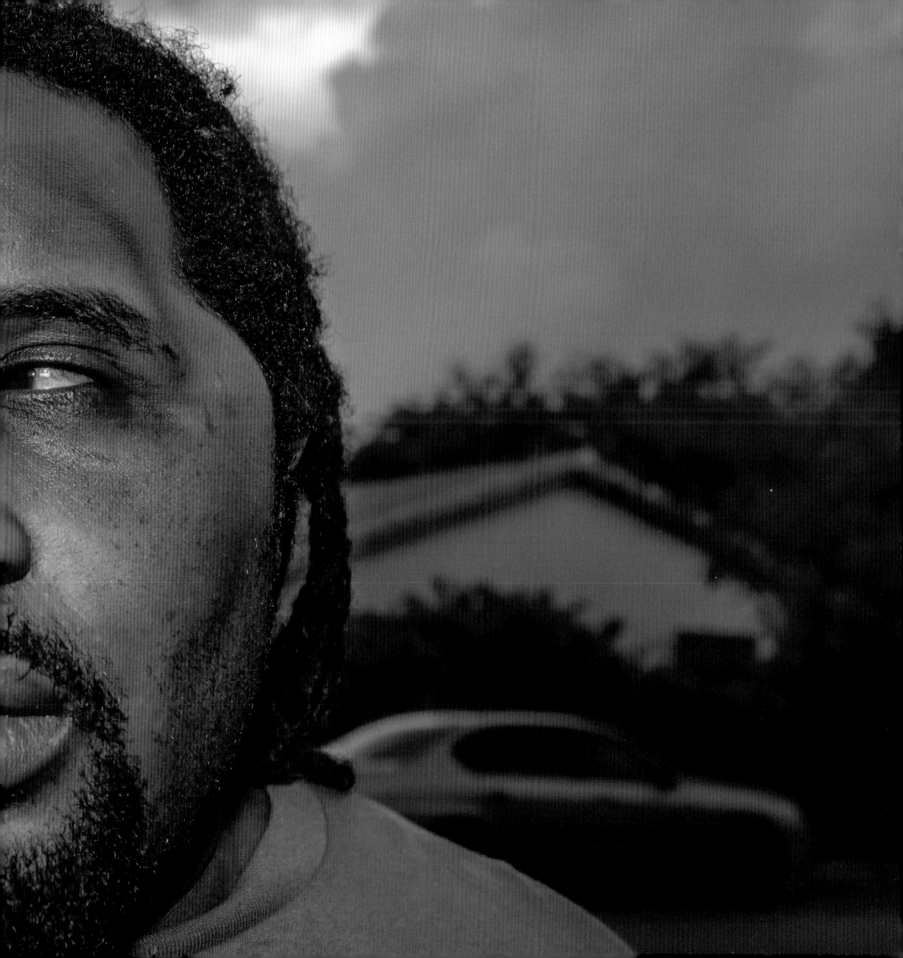

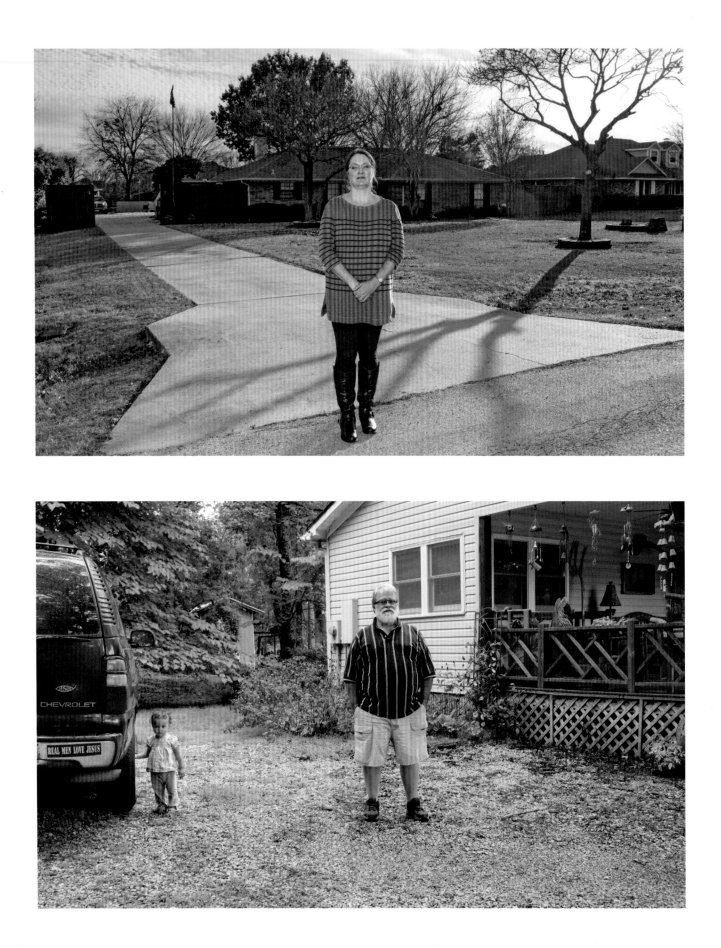

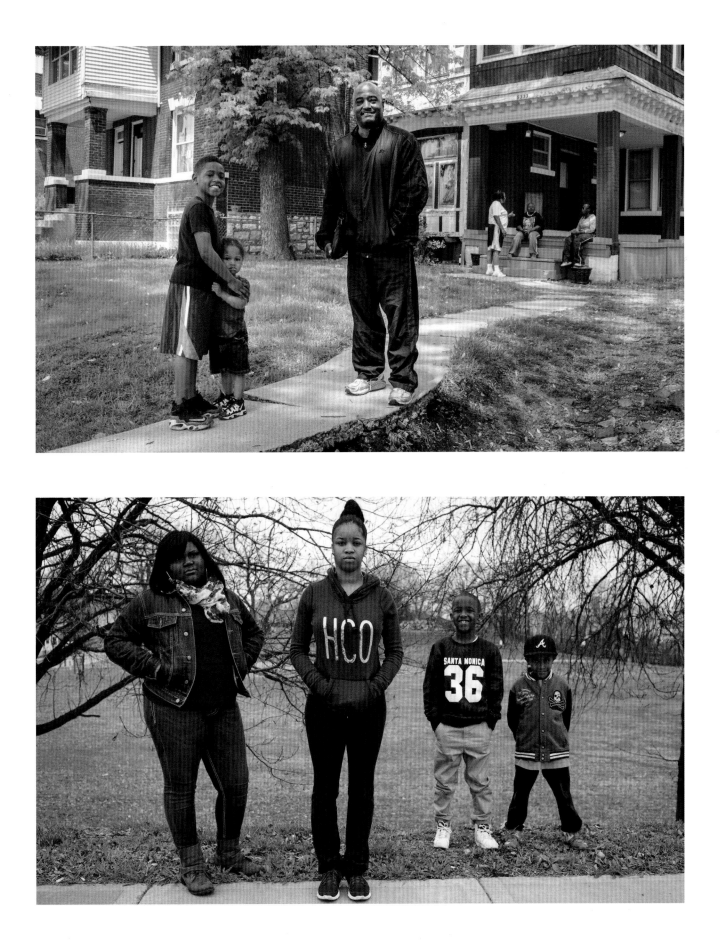

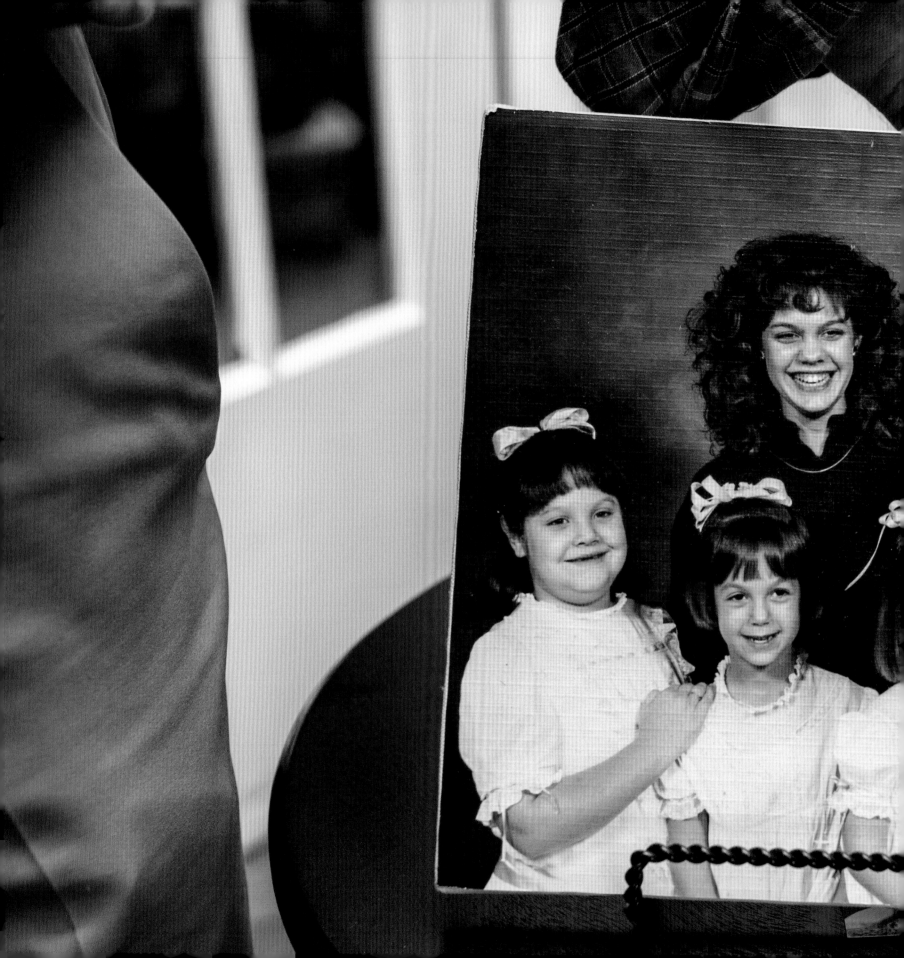

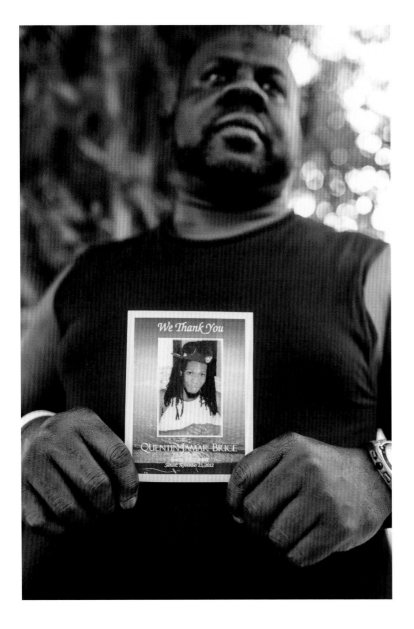

I'm a three-time survivor of gun violence.

Joe Wilson

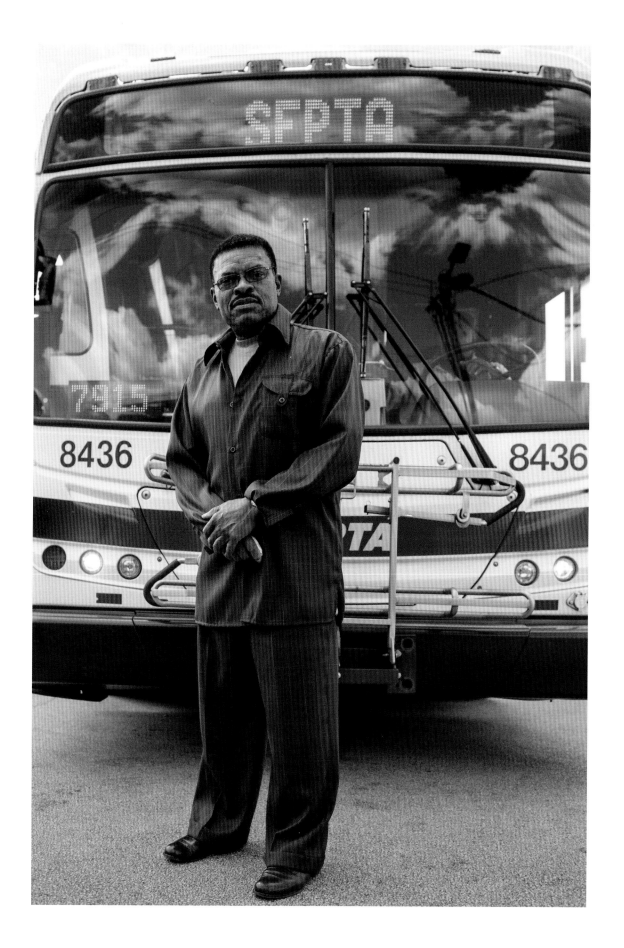

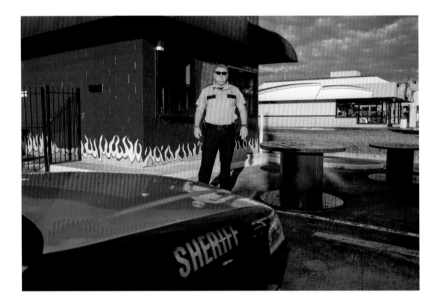

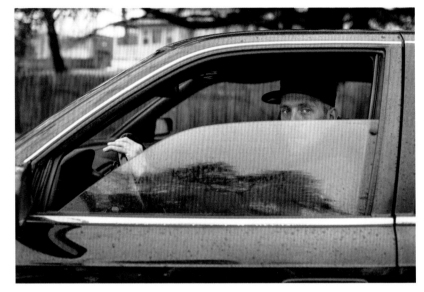

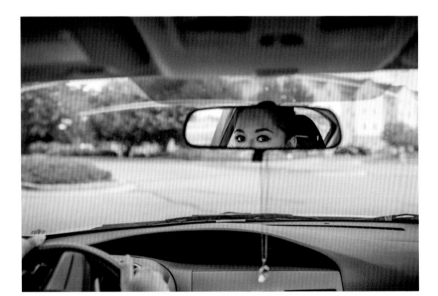

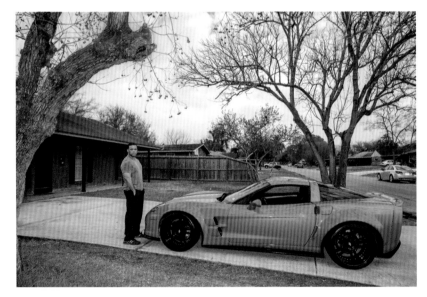

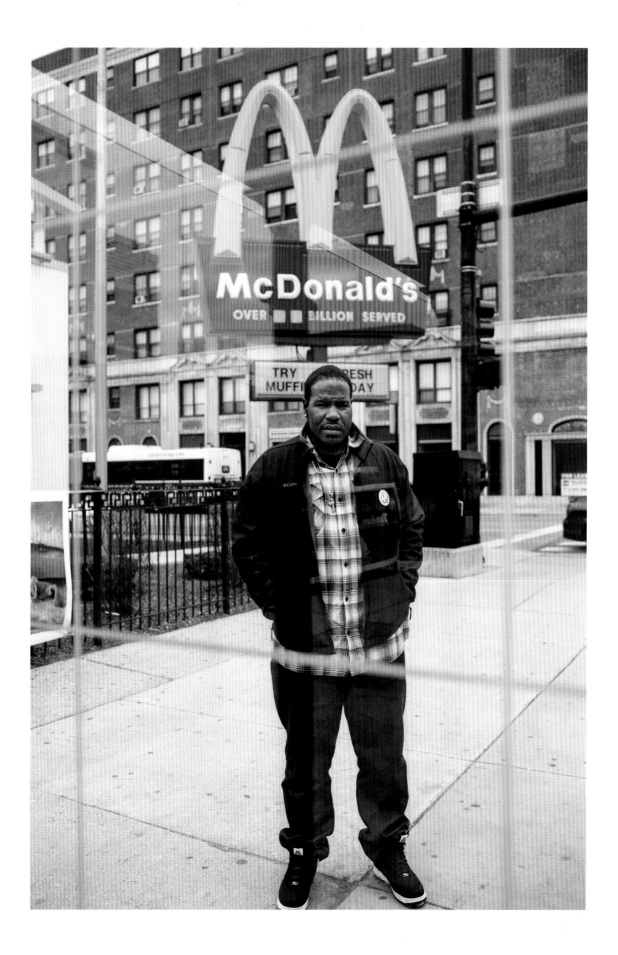

Shock followed when it sank in that I must have been shot, and I turned to look up from the floor at the person who had fired the pistol and said, "Why?"

Bishop Scott Hayashi

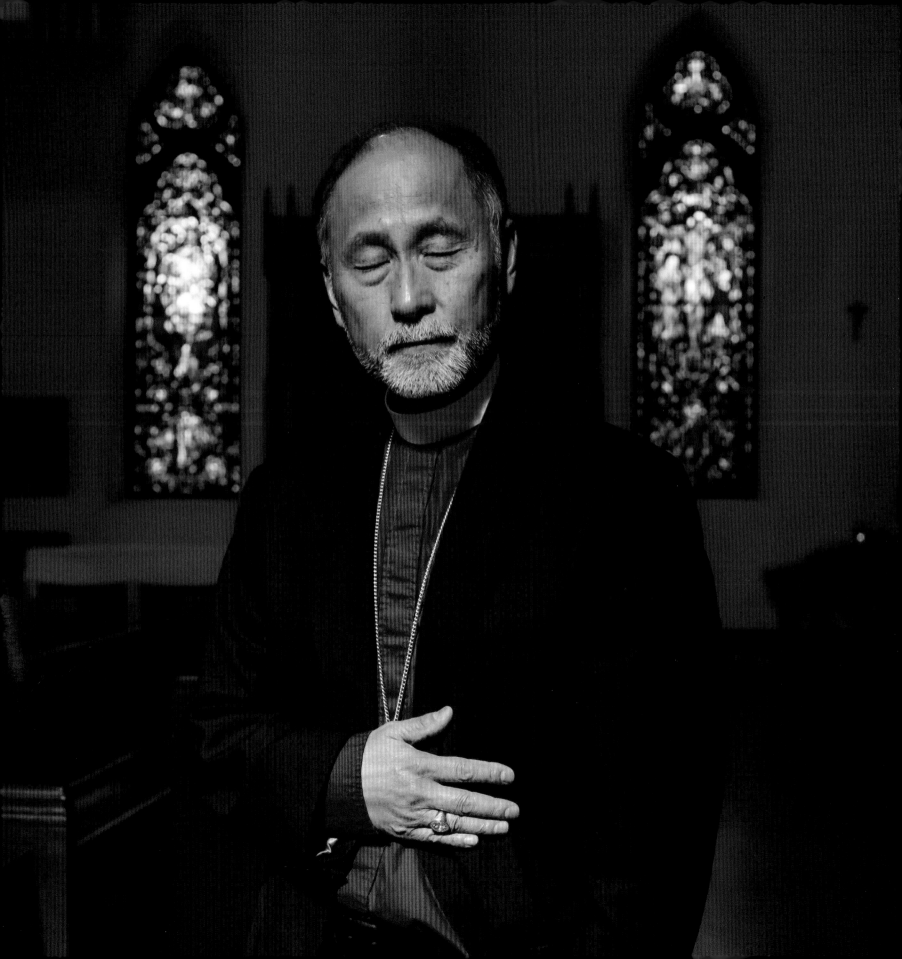

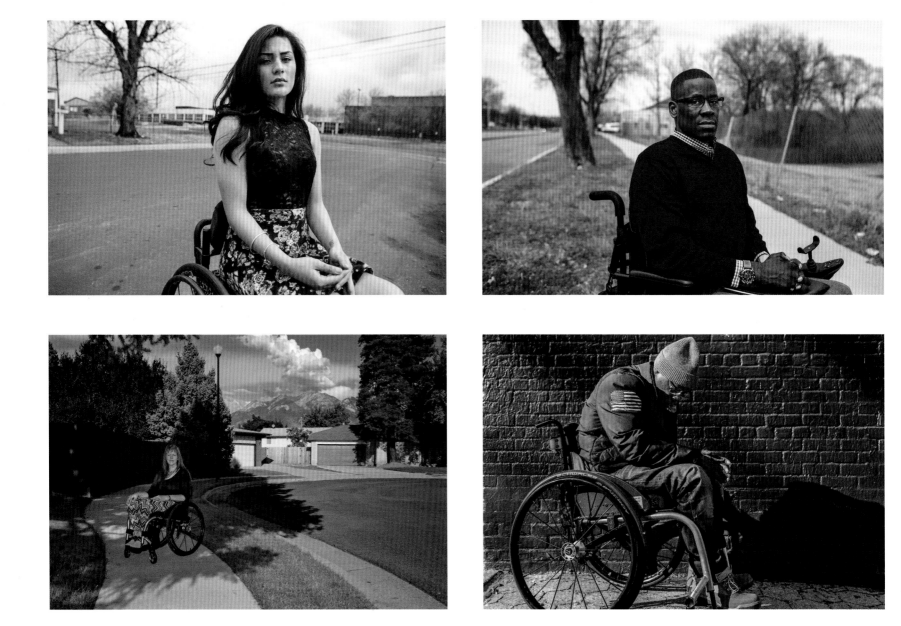

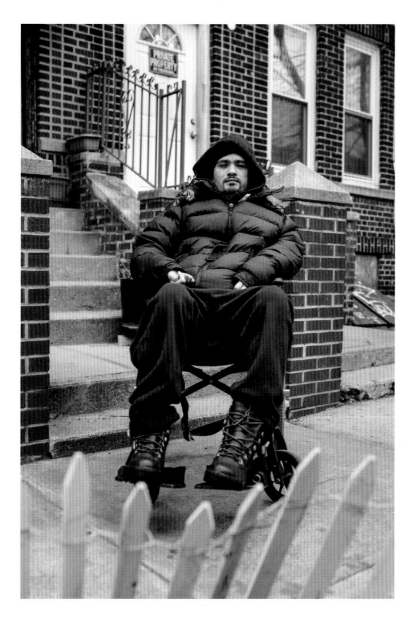
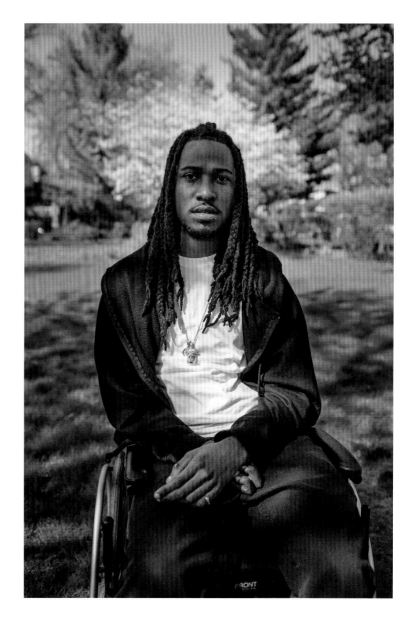

It does not hurt to die, *it hurts to* live.
Philip Gouaux

Being shot changed my life both physically and mentally. I was told time heals all wounds. Well, with that being said I hope time will come soon. I will never forget how it felt to be fighting for my life and to catch my breath. After the first shot entered my body and pierced my lung, the second entered my neck. I could smell and feel death surrounding me. But obviously God's angel was there, too, because I survived.
Shanessa Pittman

I had a really bad experience going through the things I went through. Kids making fun of me, having to learn how to play sports again, having to learn how to ride a bike again.
Tyrek Marquez

On August 26, 2007 my "could not get worse" got worse when my ex-husband shot me in the head at point-blank range.
Sheriff's Deputy Shyrica Wesley

My mom told me I shouldn't be dating a drug dealing bad boy; that I deserved way better. I wish I listened.
Janelle Sippel

I understand now that for each victim there is a wide network of people who are also deeply affected, whose sense of security in their own lives and the lives of their loved ones will now be irreparably shaken by the simple pulling of a trigger.
Brian Ludmer

I was shot point-blank in the face and arm with a hollow-point .45 by my abusive boyfriend Kenneth in a botched murder/suicide.
Courtney Weaver

I was eight years old the Halloween my brother shot me in a fight over my cat. As I hopped off to the bathroom to die in the bathtub, thinking it would be easier for my mom to cleanup, he followed behind apologizing and telling me he didn't mean to do it. That was the very last time words were ever passed between us about the shooting.
Liz Hjelmseth

I still loved him after the deed was done.
Keiba Young

When I got shot, I took it as if it was something that comes with the street life.
Dario Baxter

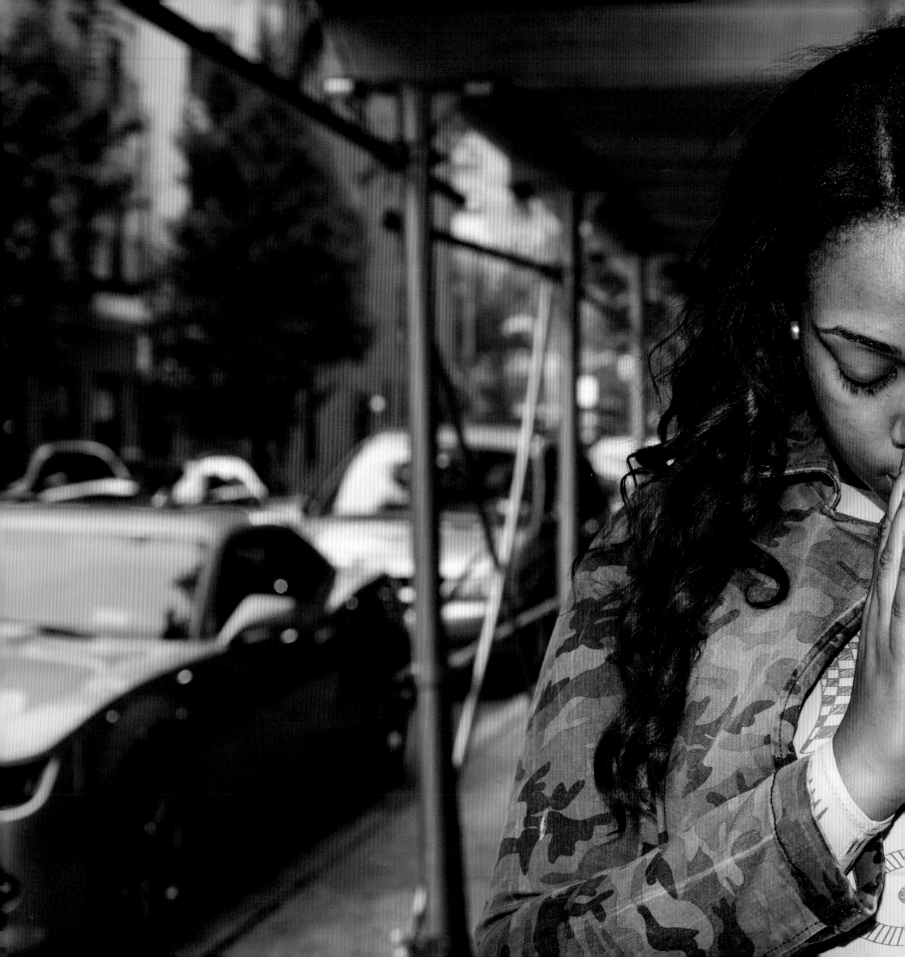

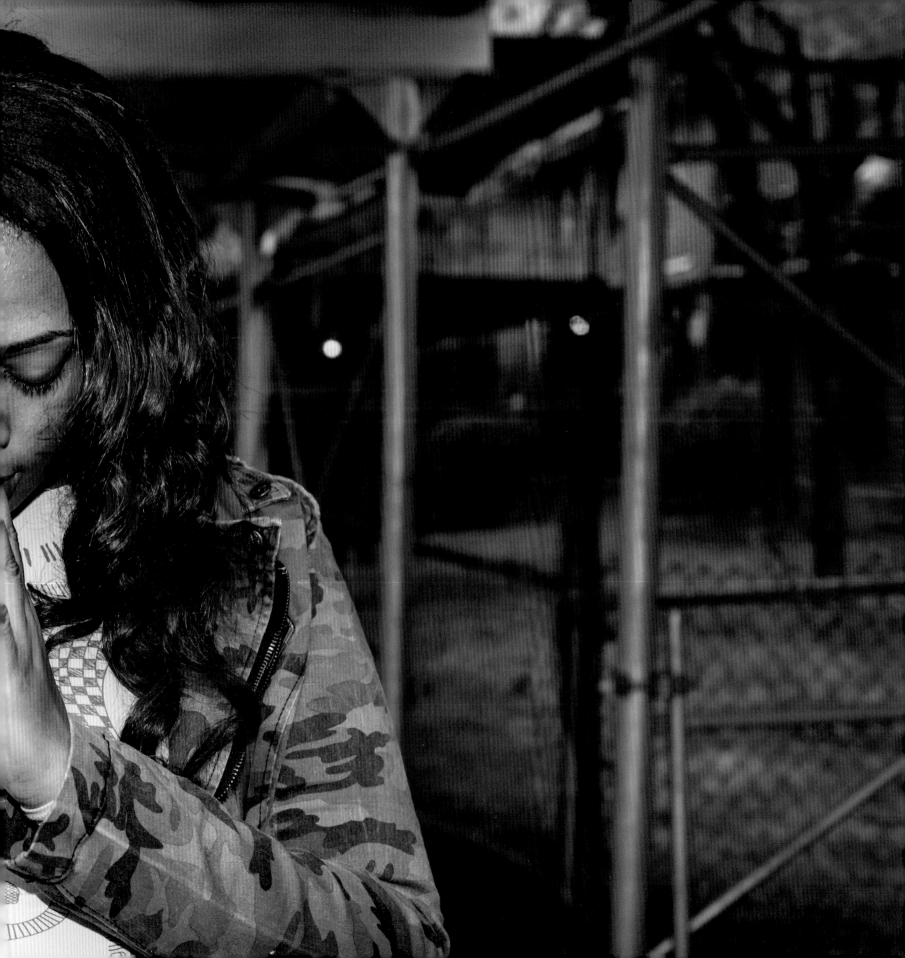

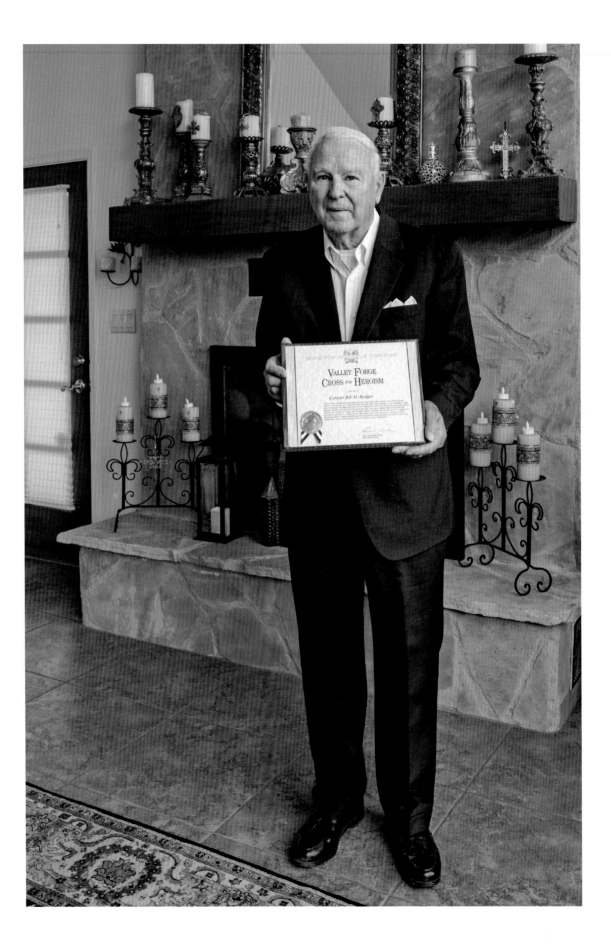

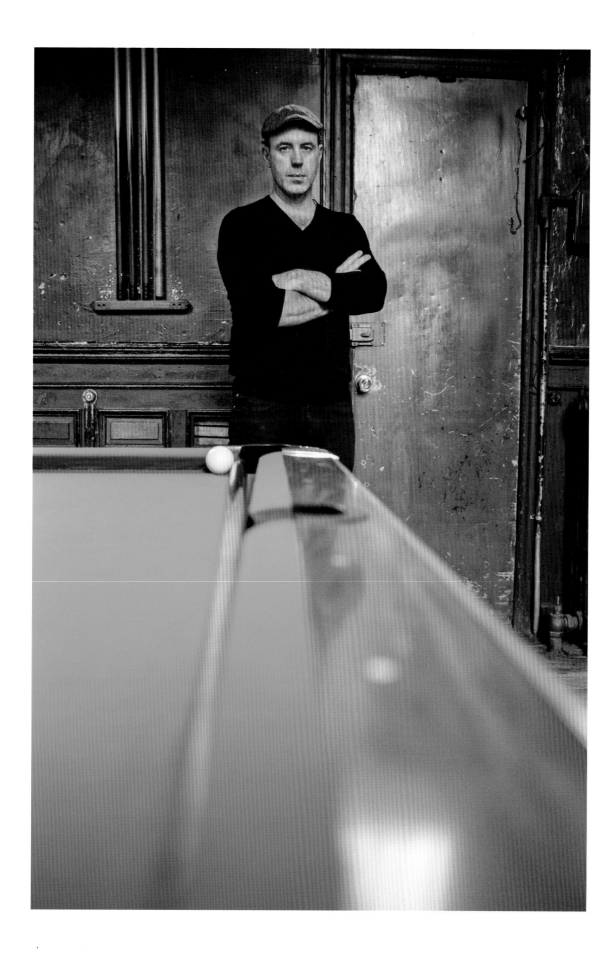

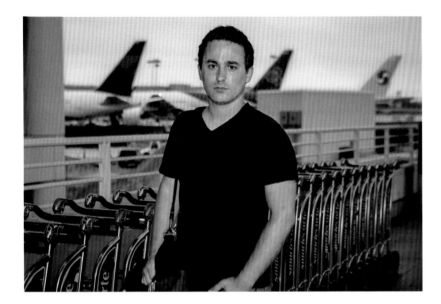

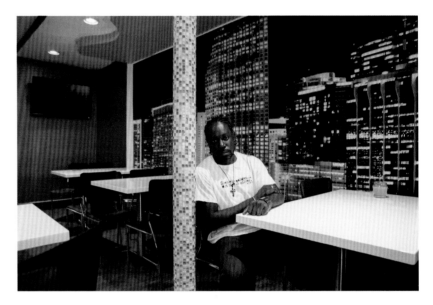

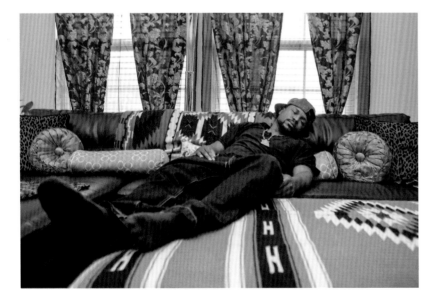

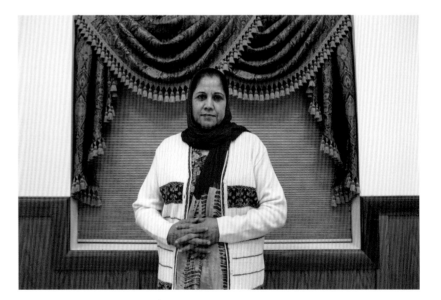

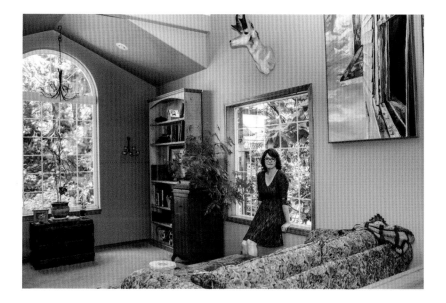

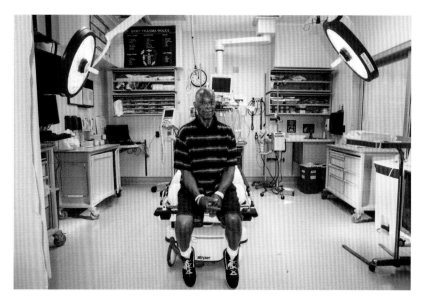

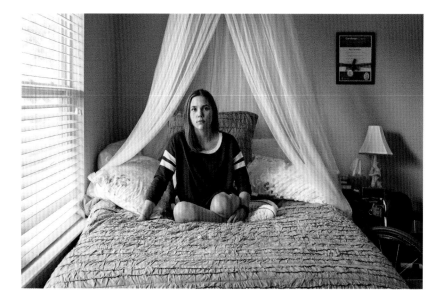

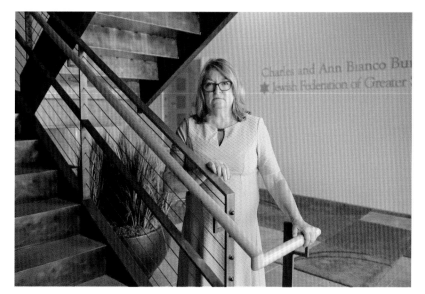

After being shot eight times in front of my house, I wrestled the shooter down and tried to incapacitate him. At that point, I drew my gun from my pocket and I shot at him.
Jeff Droke

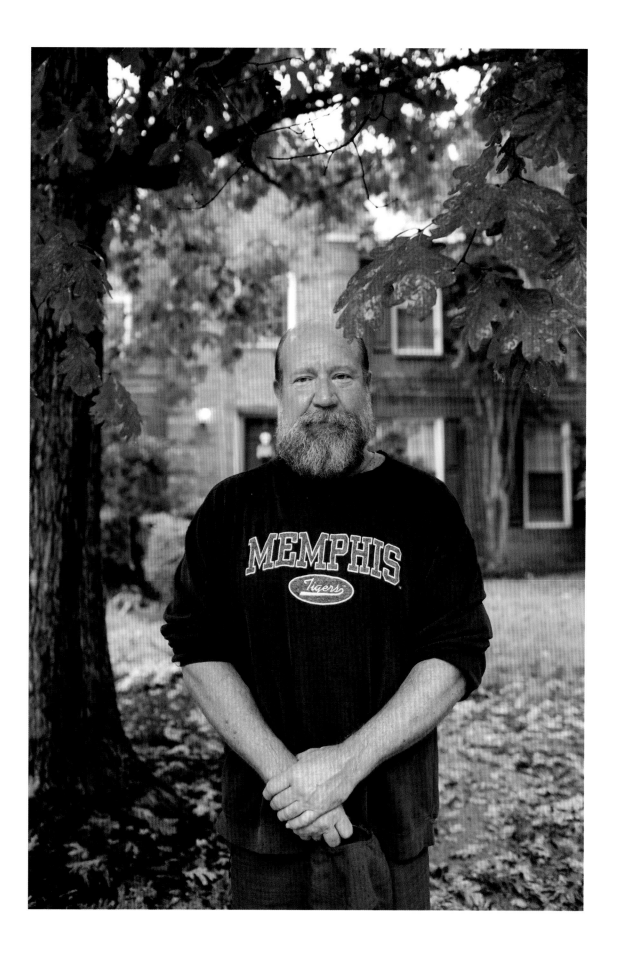

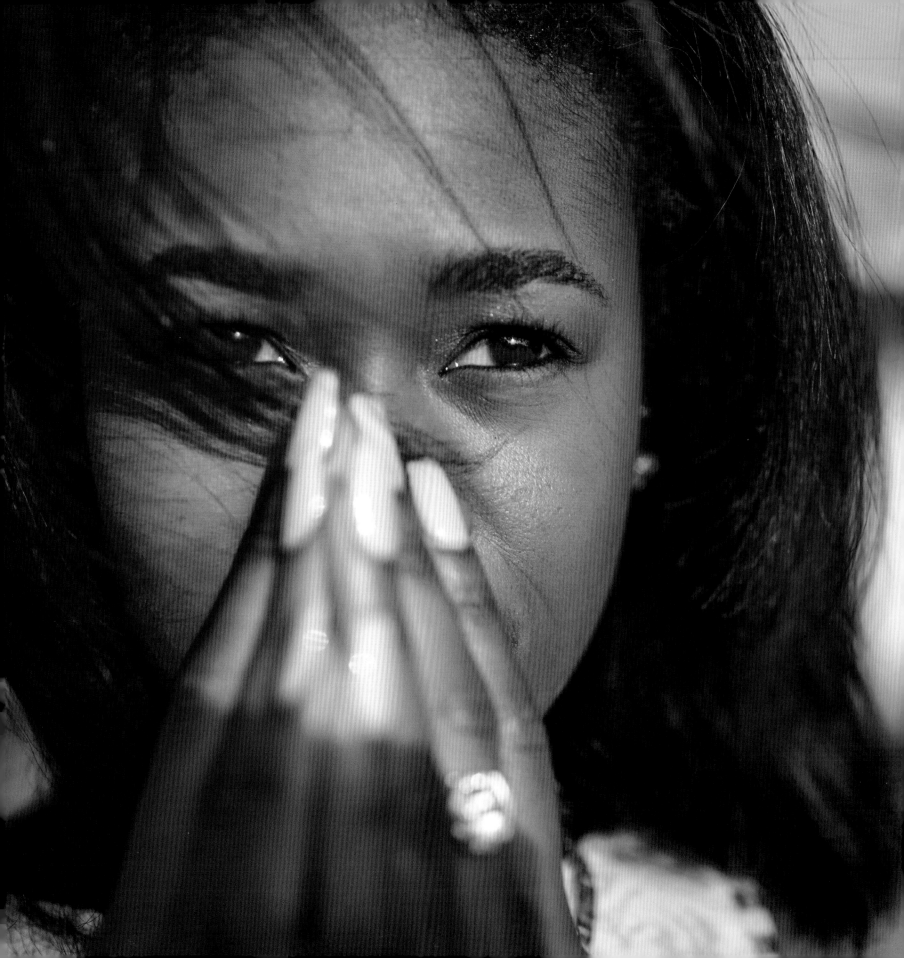

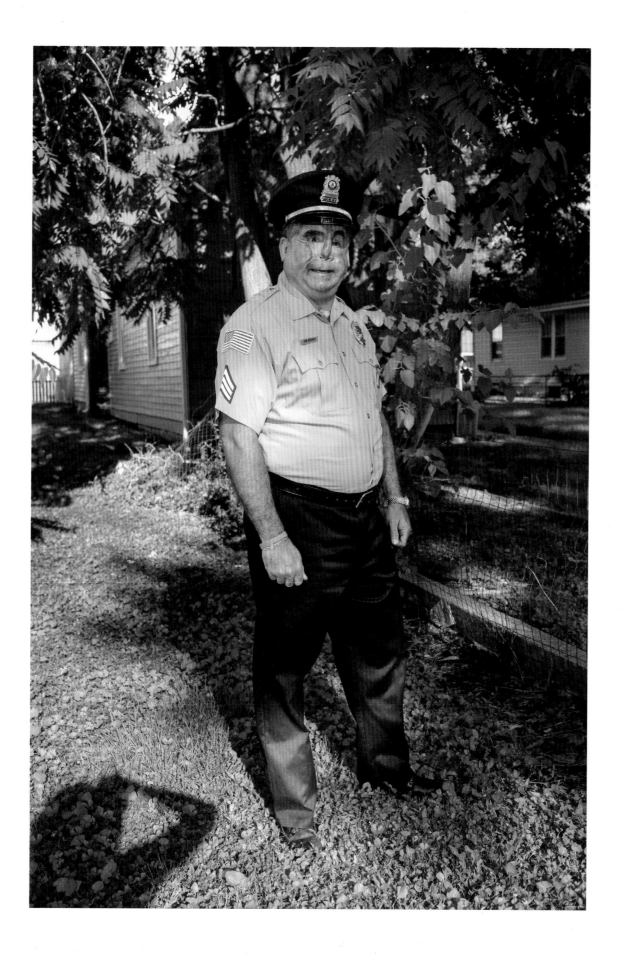

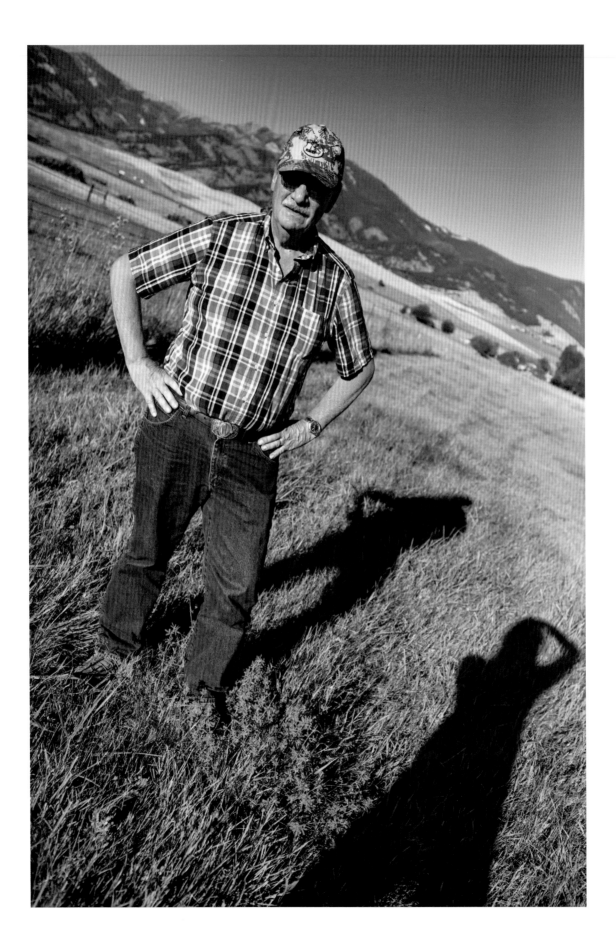

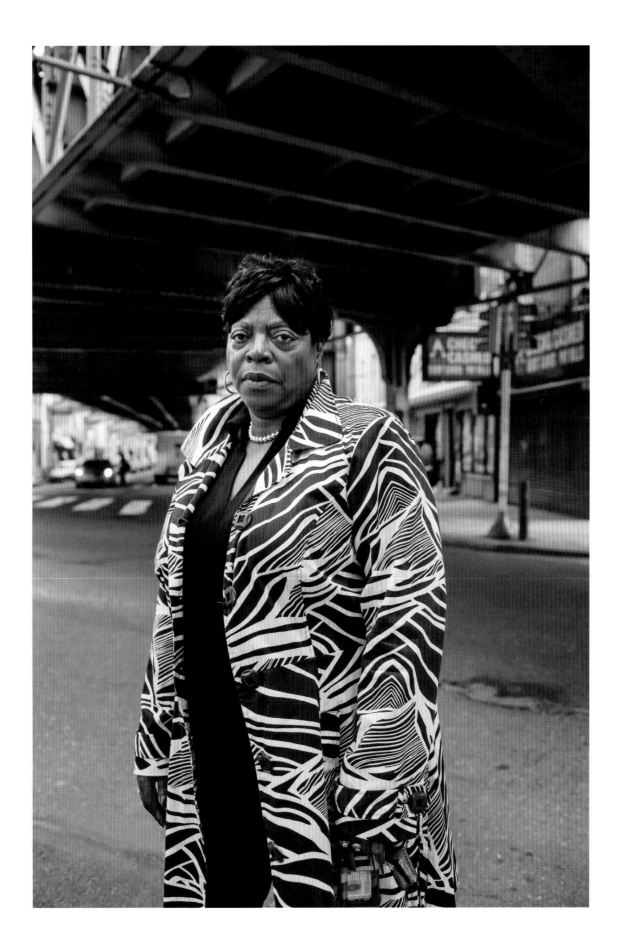

My then four-year-old son witnessed the entire event from beginning to end. He cried and begged his father, "Don't do it! Don't shoot Mommy!"

Kate Ranta

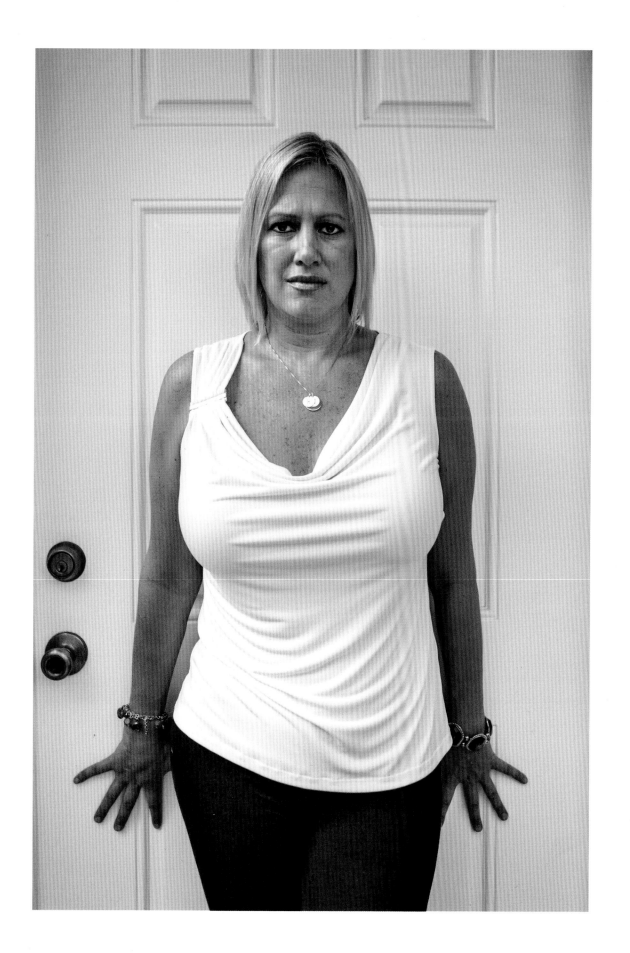

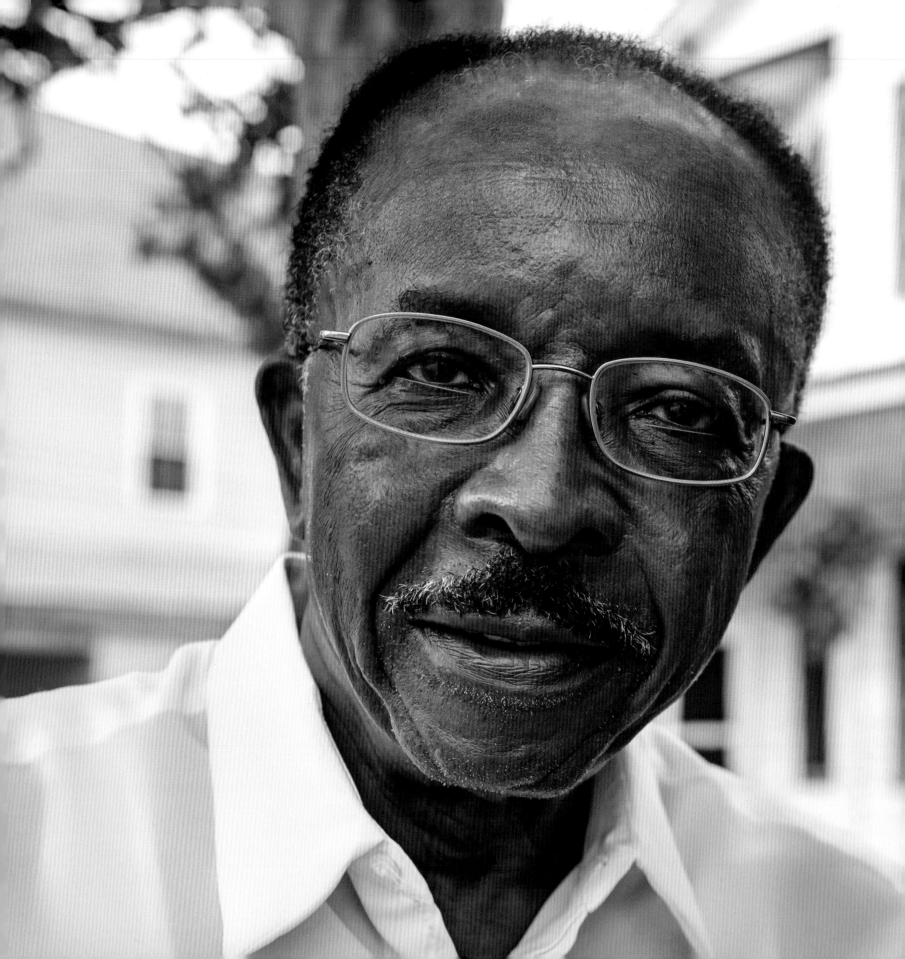

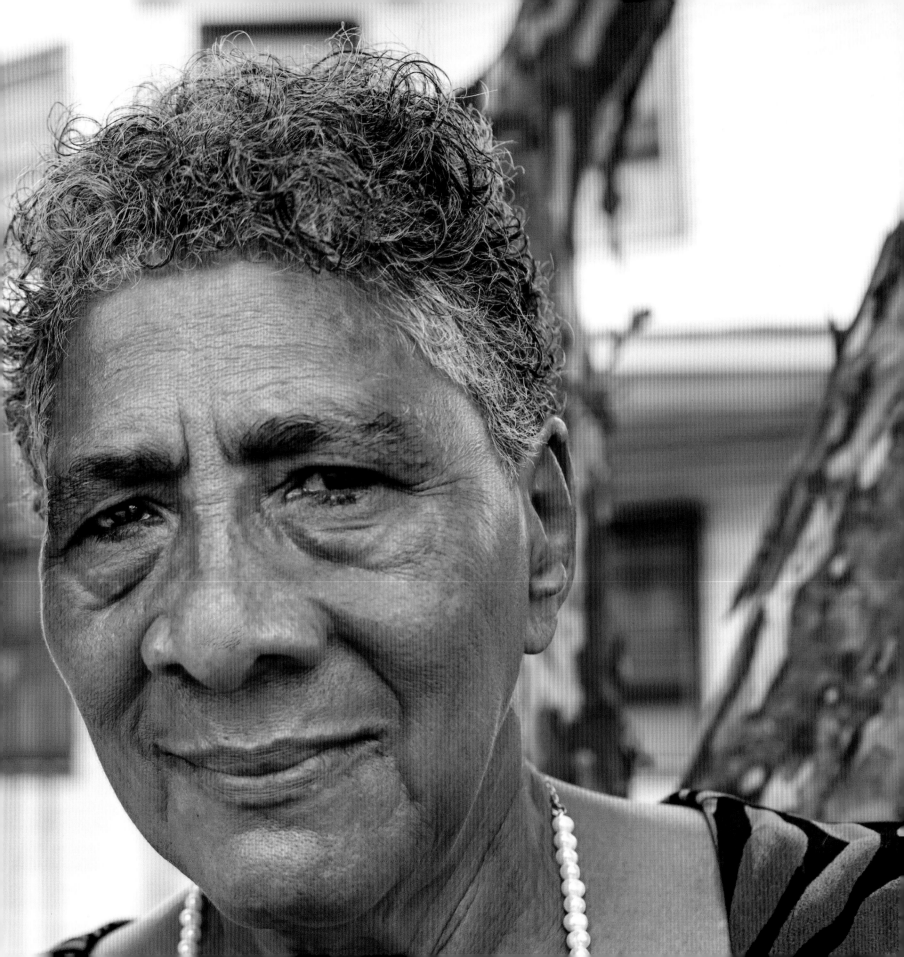

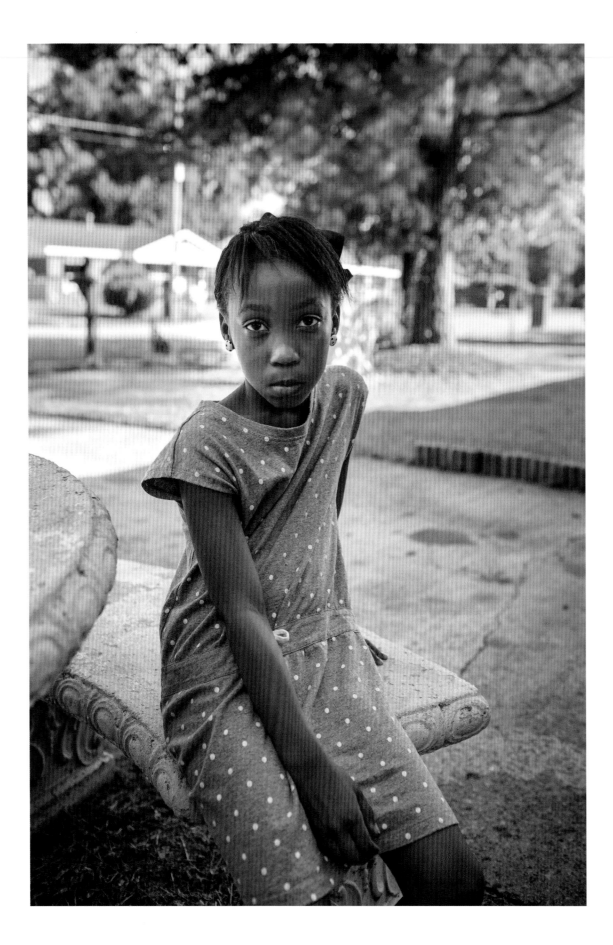

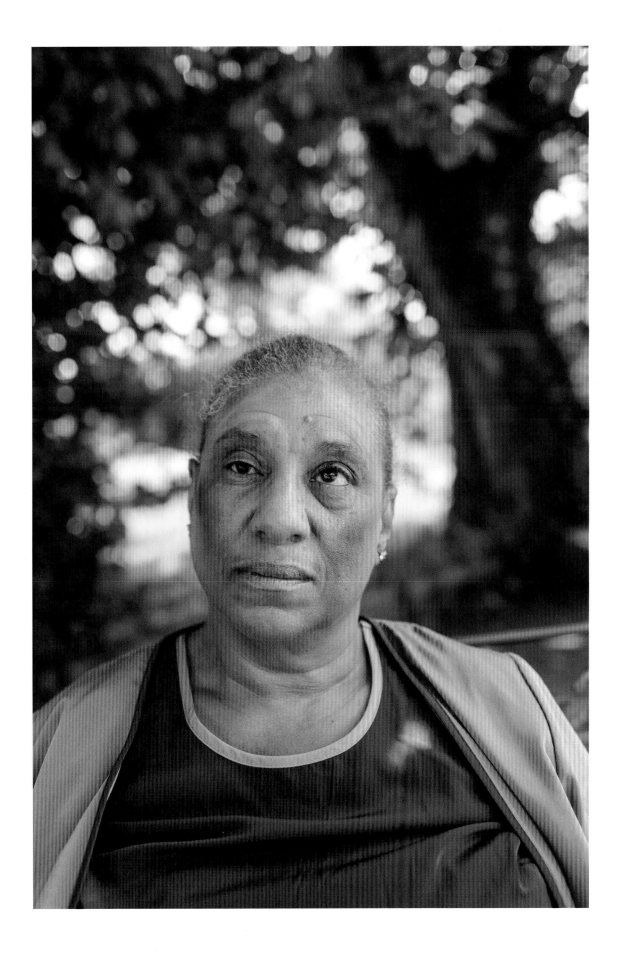

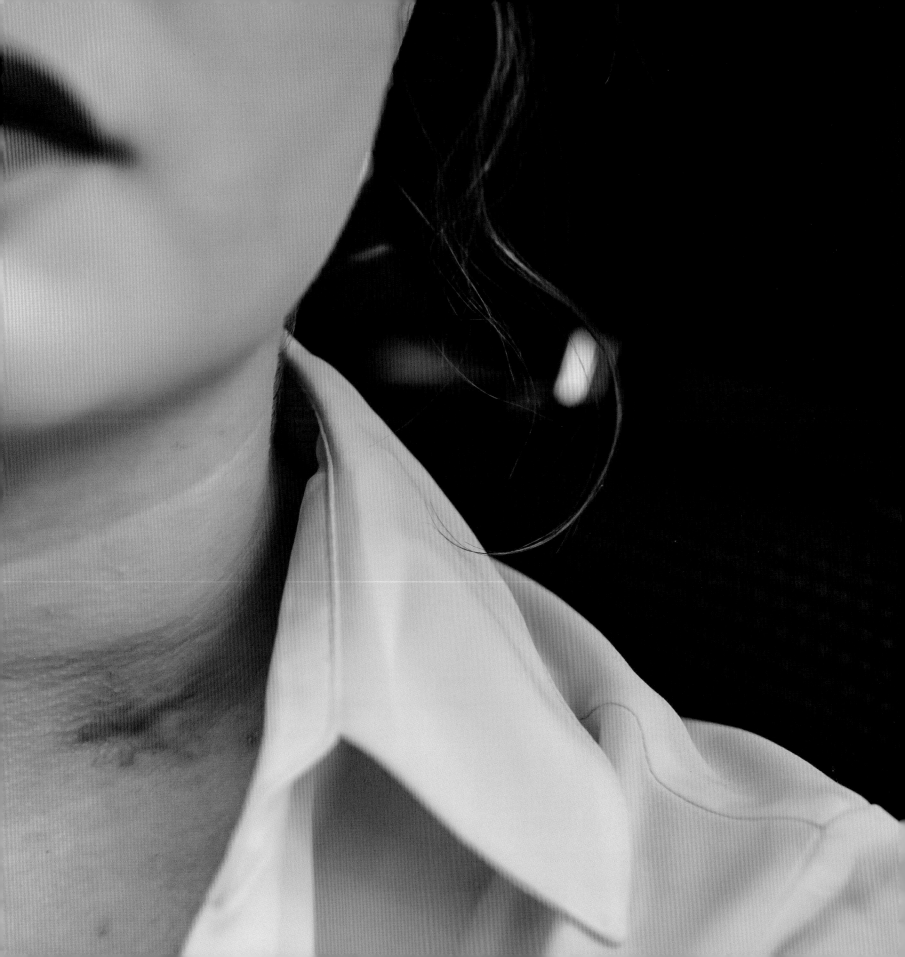

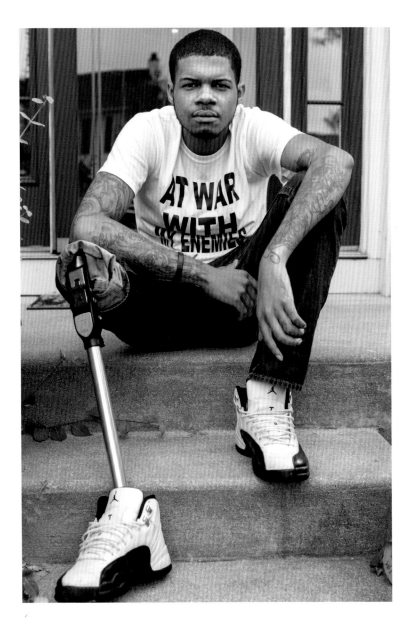

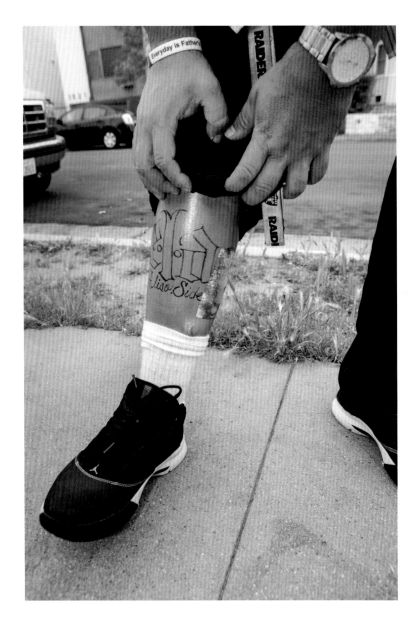

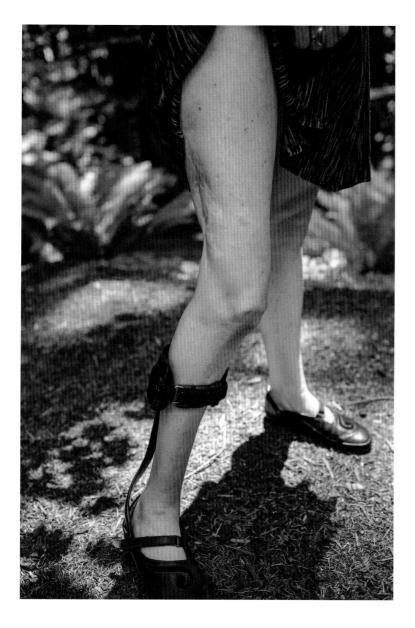
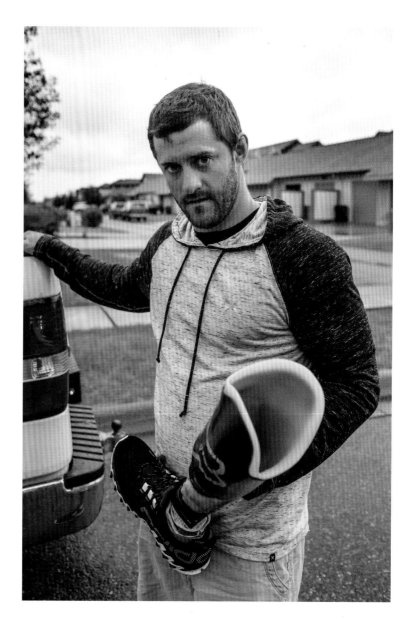

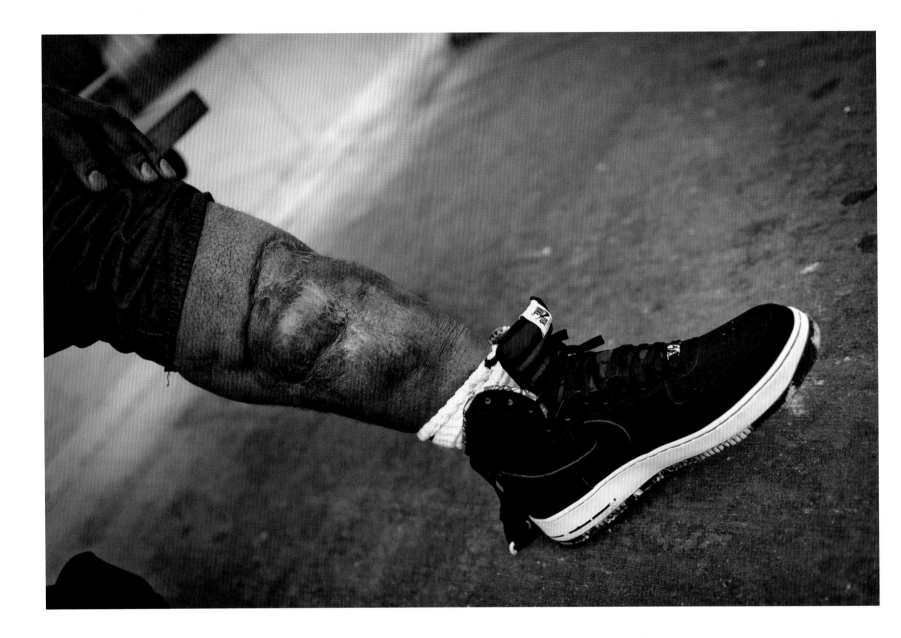

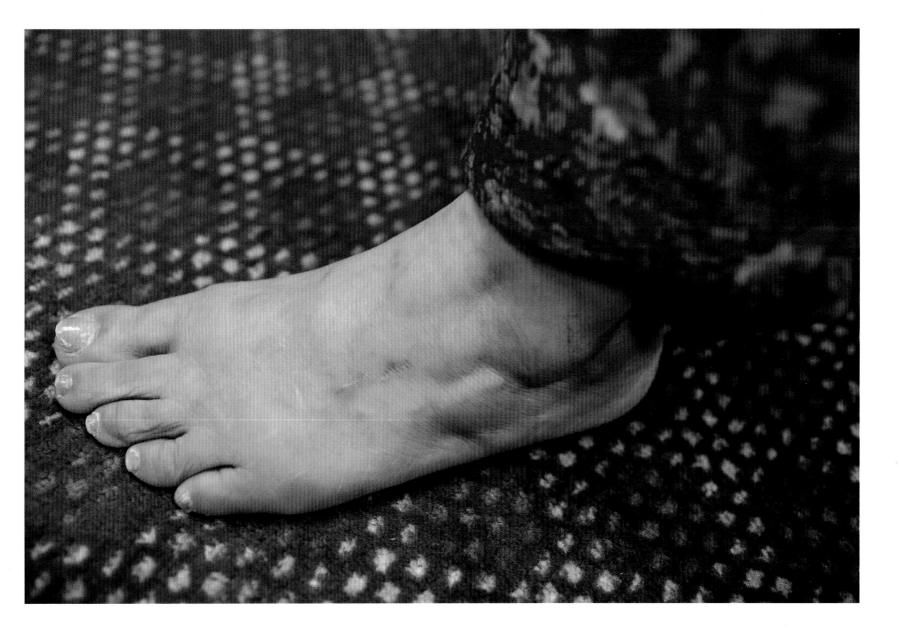

The emotional impact of being shot and left for dead on a quiet Berkeley street will be with me forever. I knew even then that I could become better or bitter. I decided to use my traumatic experience for the better.
Gabrielle Schang

Scars are stories. I used to joke and say I wanted scar removal surgery but it's a miracle I'm alive and my scars tell that story. When I first discovered the SHOT project, it was the scars pictured that captured my attention. It's what continues to connect me to people all over.
Megan Hobson

Everything is either an opportunity to grow or an obstacle to keep you from growing. You get to choose.
Thérèse D'Encarnacão

People tell me all the time that I am a lucky girl. Which is true because I am. I am lucky to be alive. I'm lucky to have basically survived. But what nobody understands is that once you have gone through such a traumatic experience, it takes everything in you to make sure that your happiness and stability survives too. I'm not the same girl I was before this, but one day I know I will be better than I used to be.
Cori Romero

I got the best of the situation, I didn't let it get the best of me. I always love challenges, and that's what my life has become in a good way now. Everyone in my circle has to push themselves harder because we don't believe in quitting. An old saying I heard and live by, "Winners never quit, and quitters never win."
Rayvn Richards

I think what makes me strong and what makes me an inspiration is the fact that I'm a survivor. Being a survivor of gun violence doesn't make me weak or fearful, it makes me feel powerful. I got shot and survived a bullet. Most people don't live to say that, but I did.
Martha Childress

I am not a victim but a survivor.
Donzahelia Johnson

Although this incident had a severe emotional impact on my son (I was holding his hand when I was shot and he remembers) and me, as well as a physical impact on me, I work hard every day to stay positive and keep fighting.
Alexis Star Caldwell

I have always said the shooting was the best, worst thing that ever happened to me.
Kathleen Storm

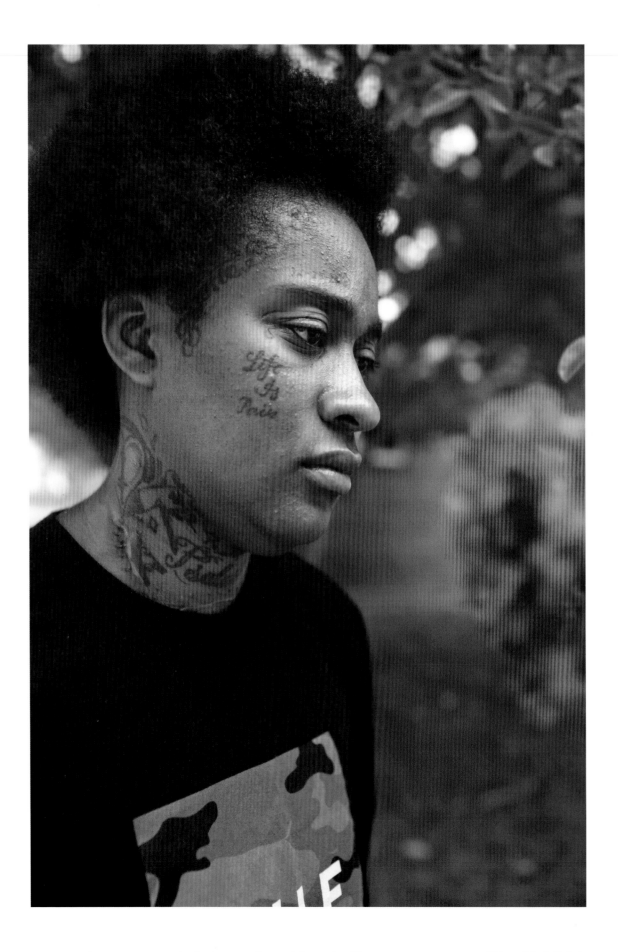

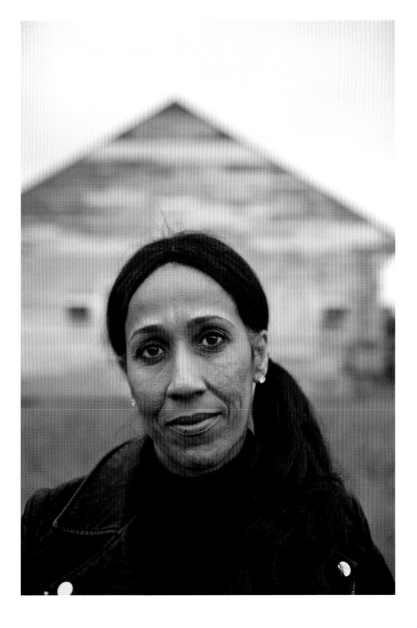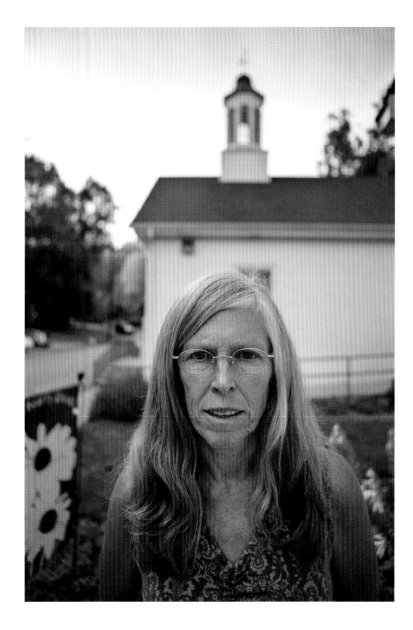

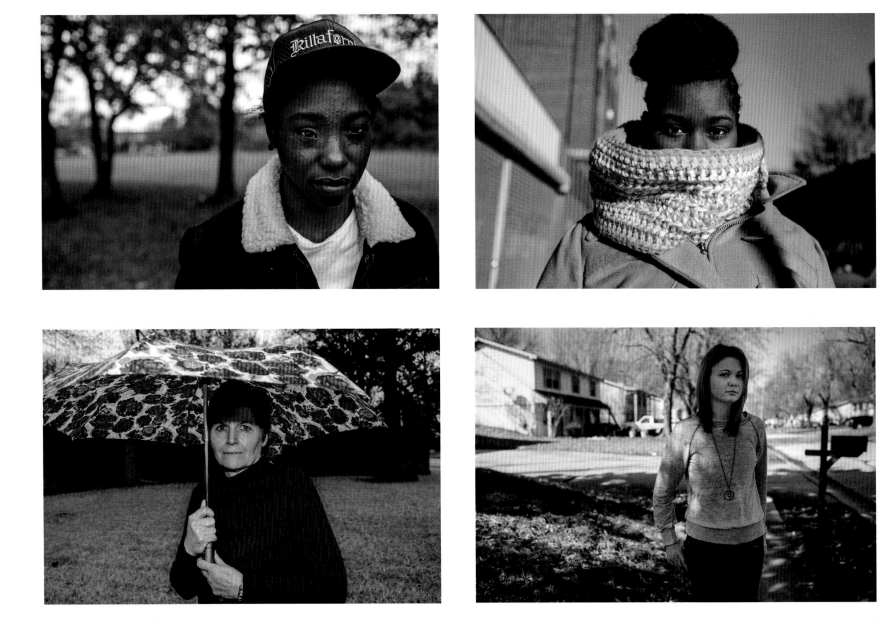

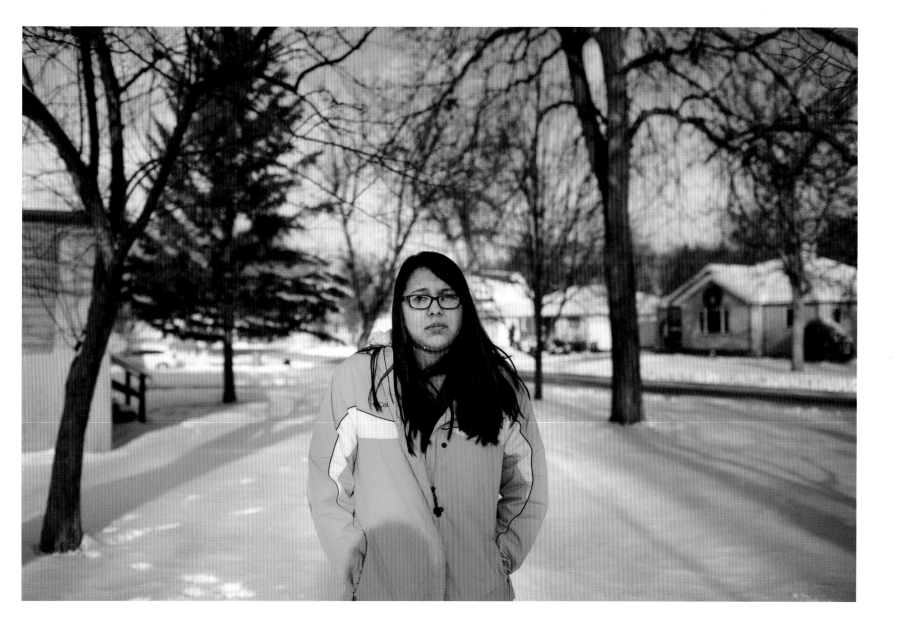

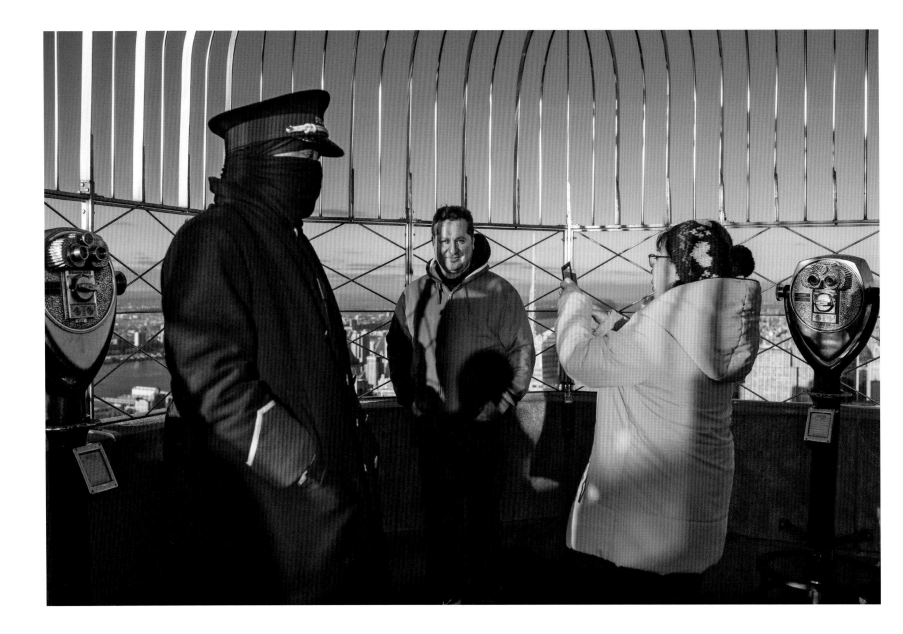

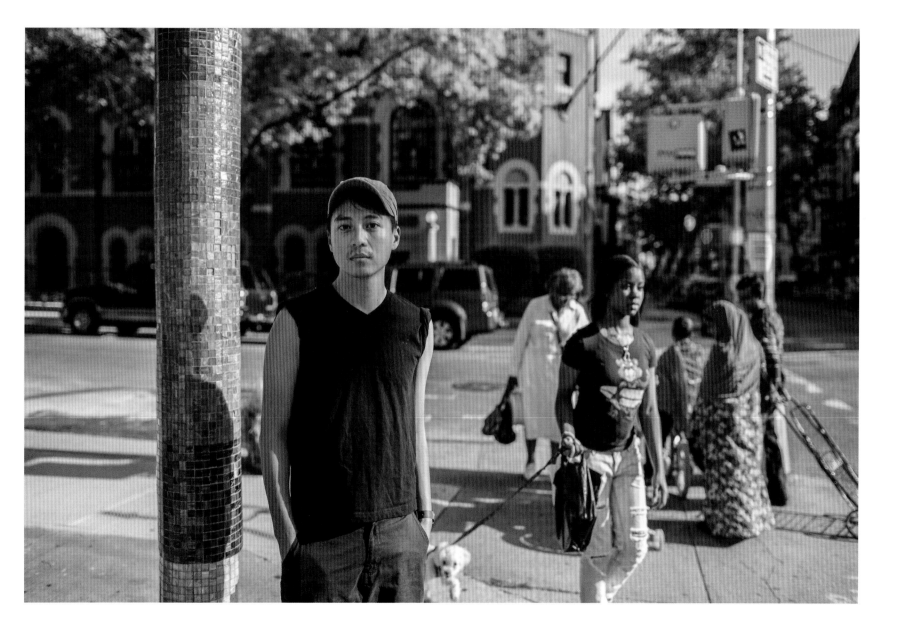

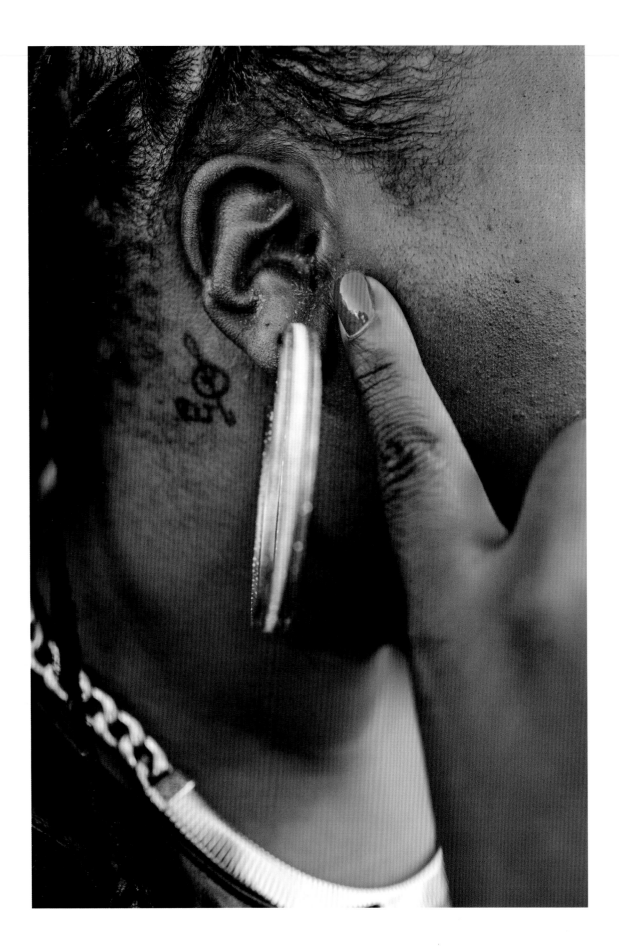

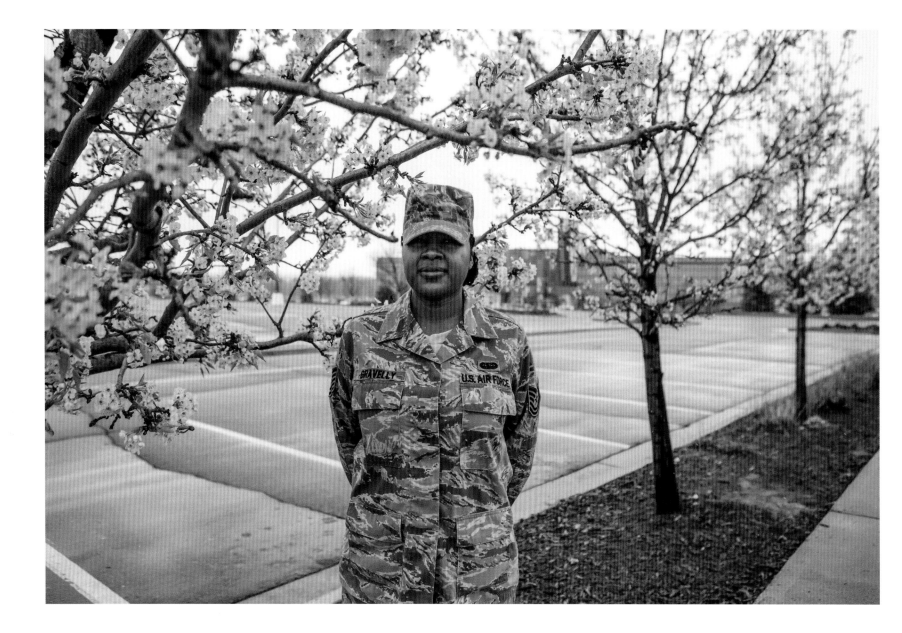

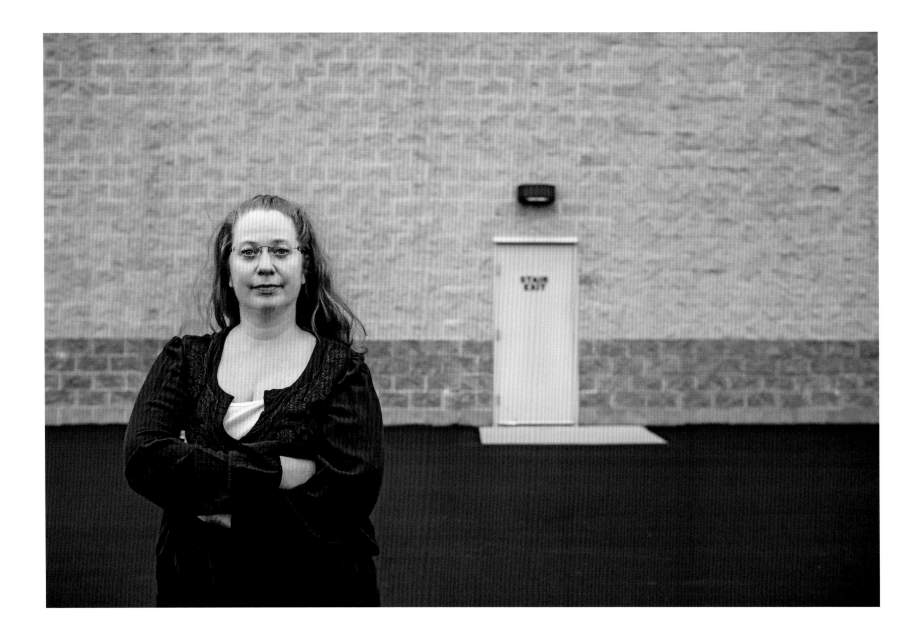

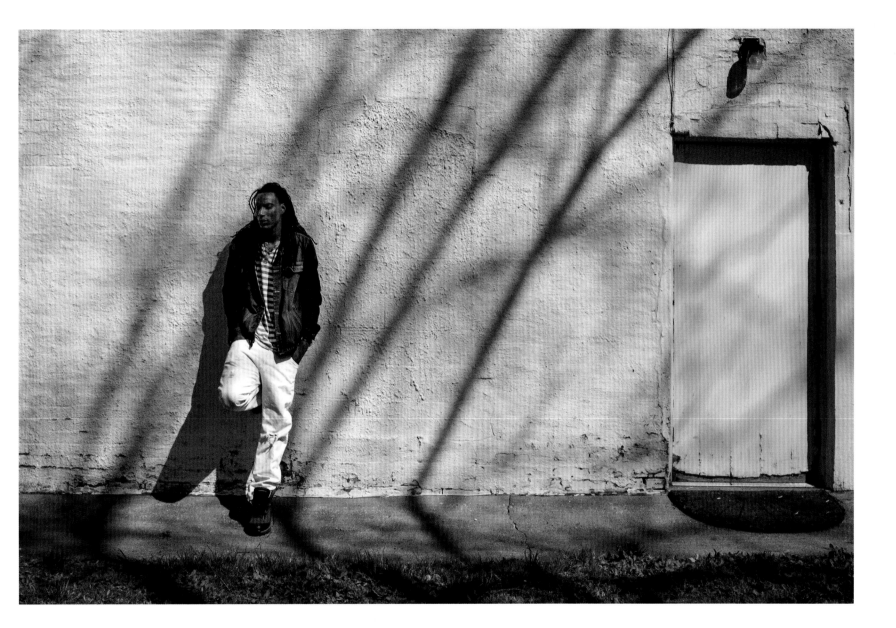

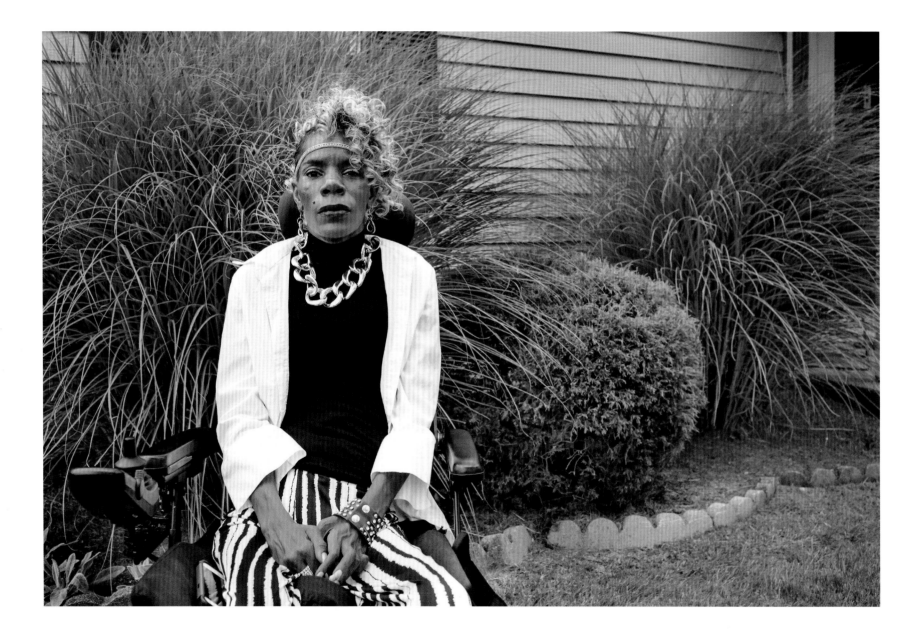

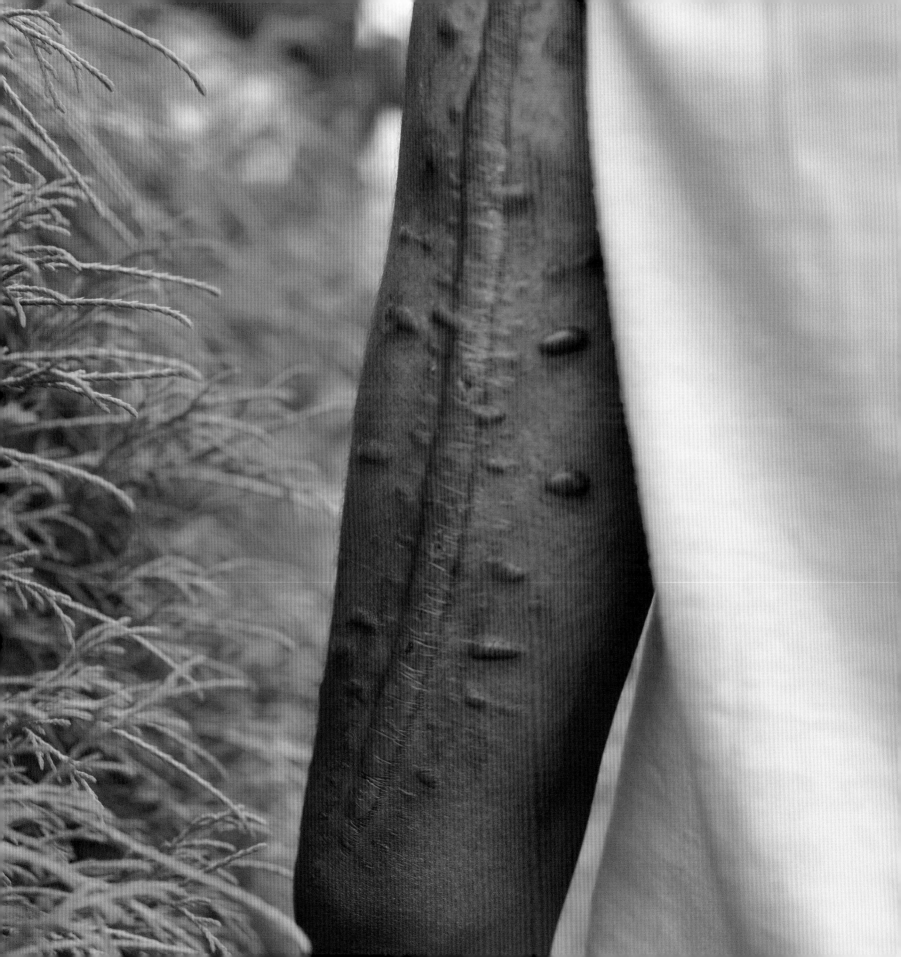

Fourteen bullets entered by body that day. Fourteen bullets that ripped through every major organ and artery. Fourteen chances to die. "I will live for you," I promised my girls as I lay on the ground watching my ex-husband flee the scene.

Shirley Justice

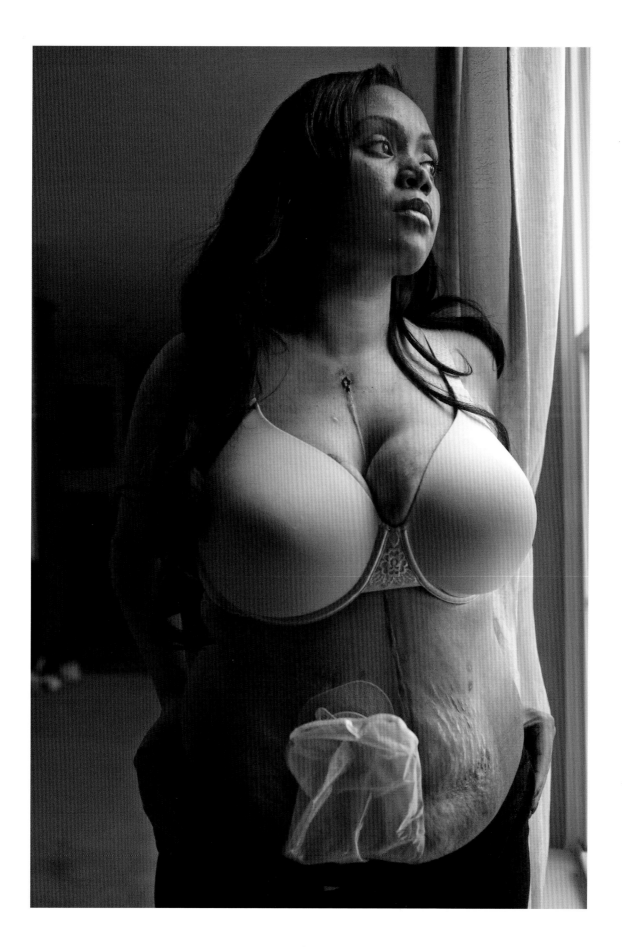

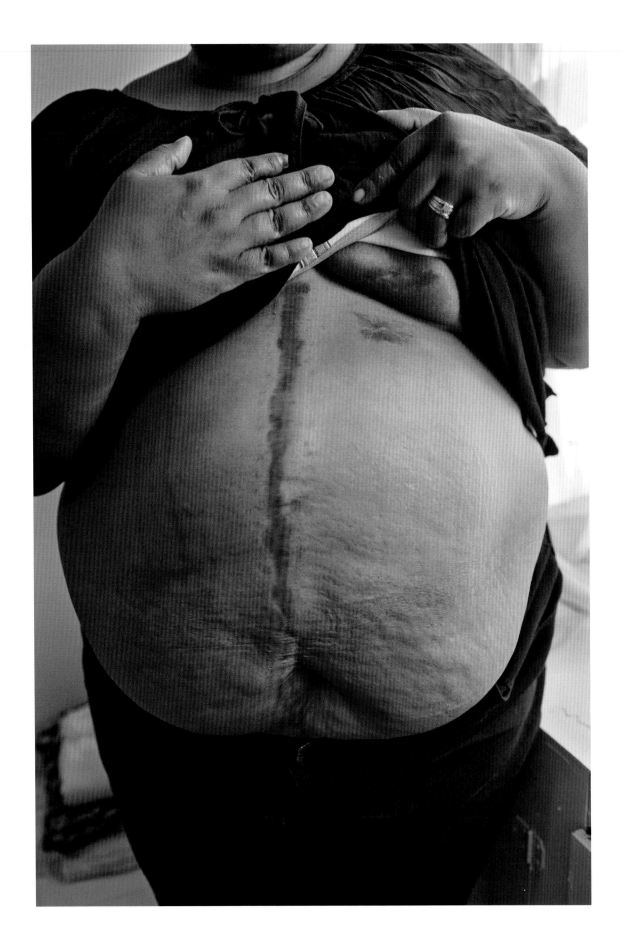

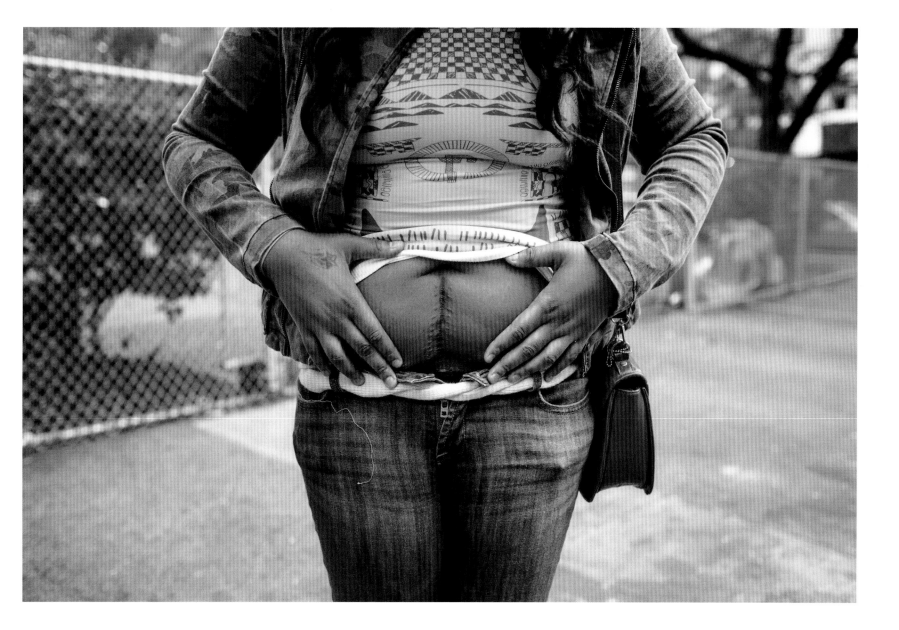

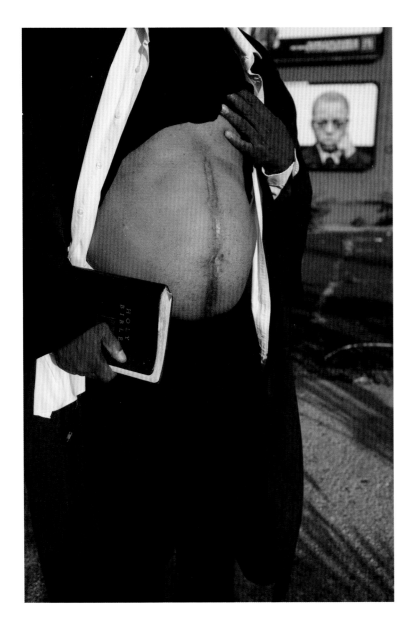
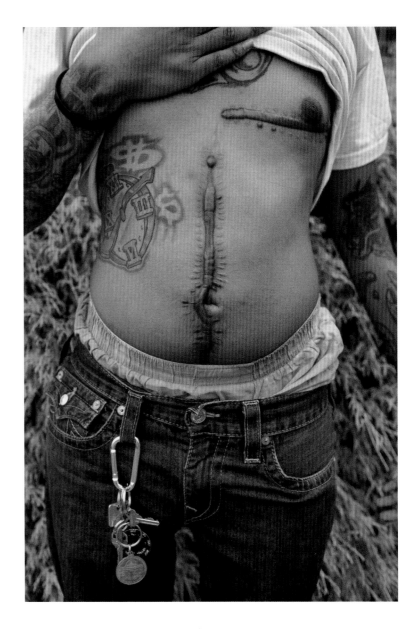

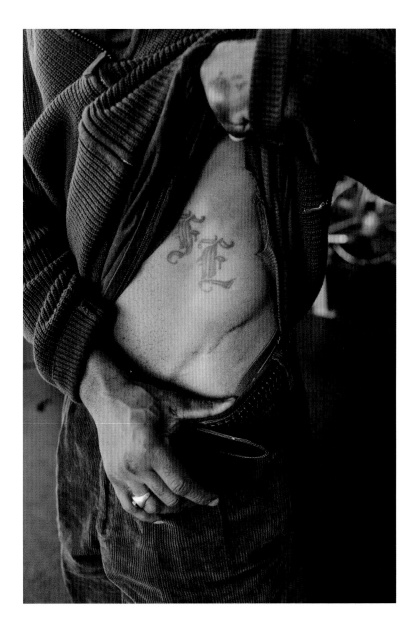
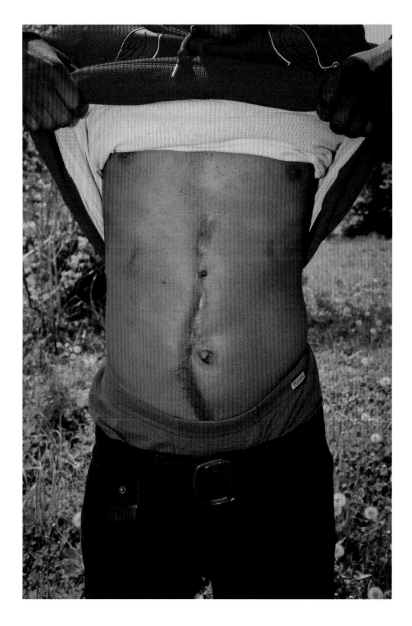

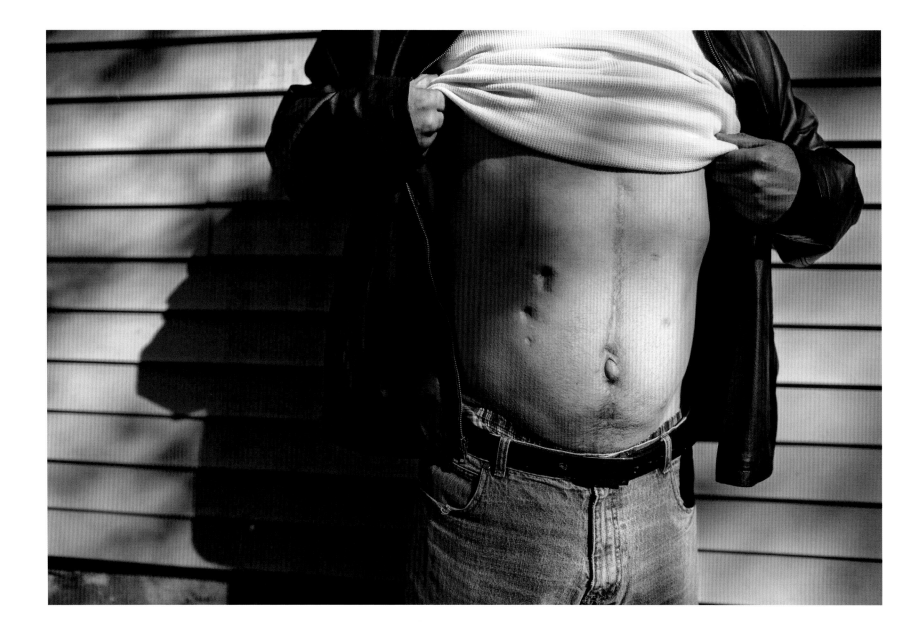

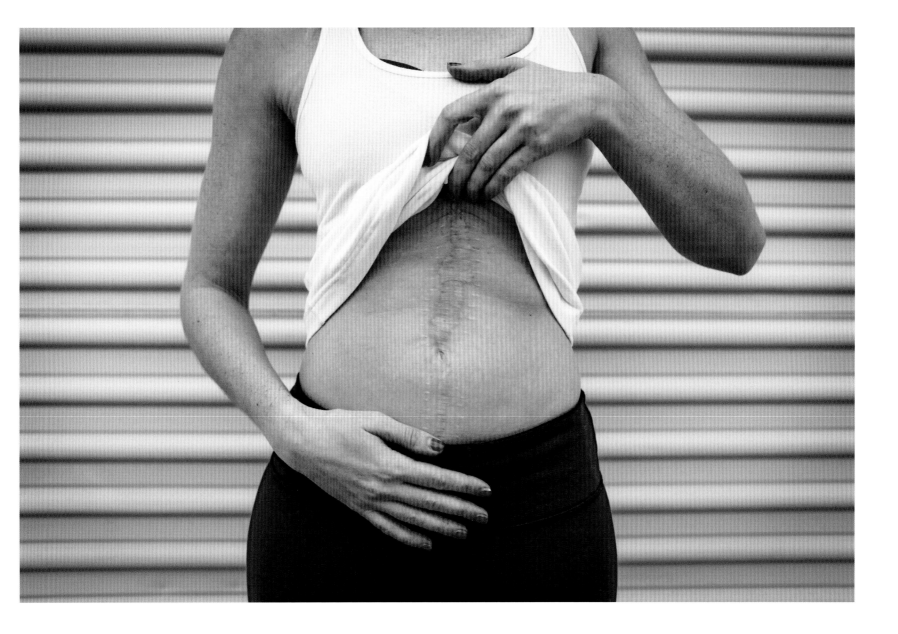

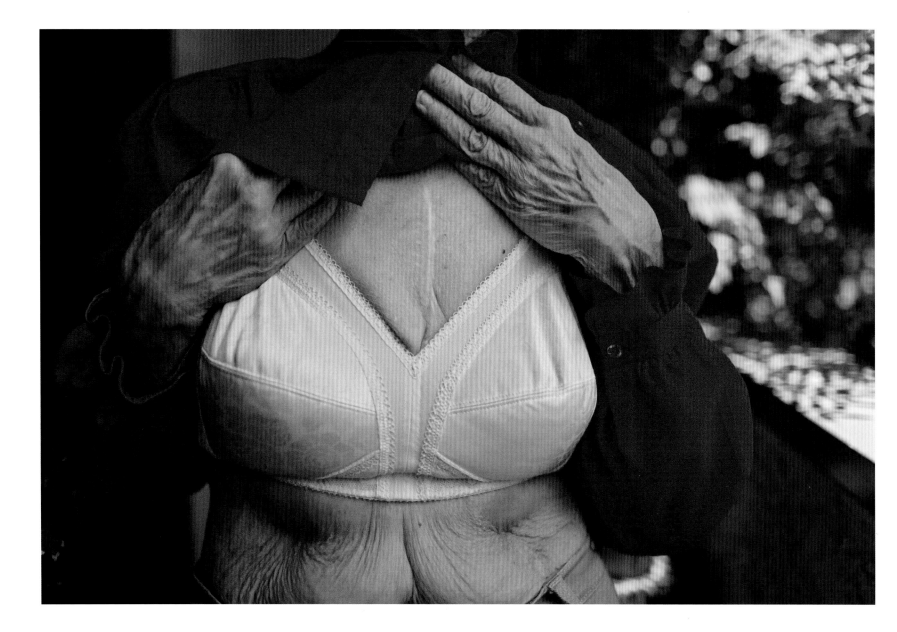

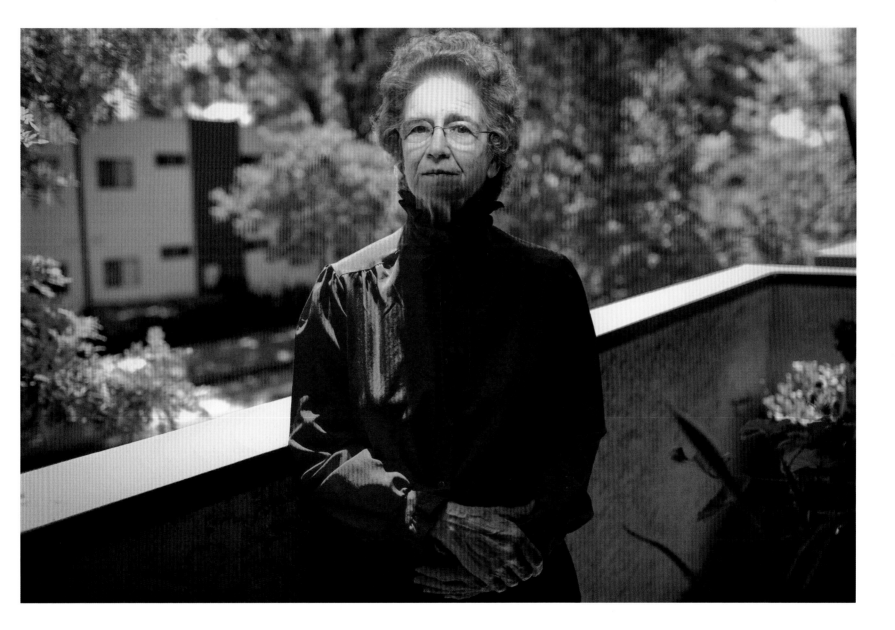

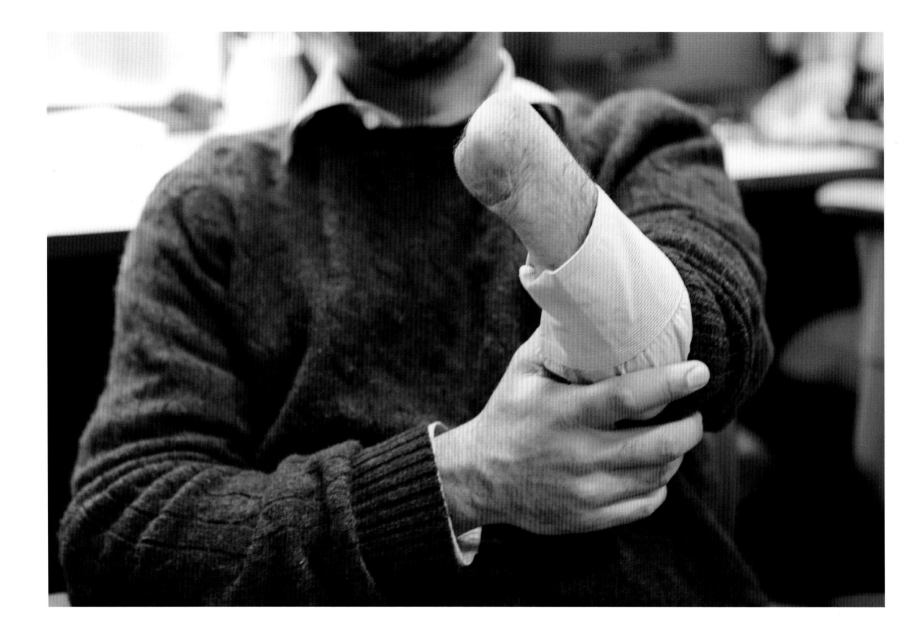

All it takes is one single minute and our lives can be completely turned upside down.
One second we are in complete control, and the next God shows us differently.
Sergeant Dayna Roscoe

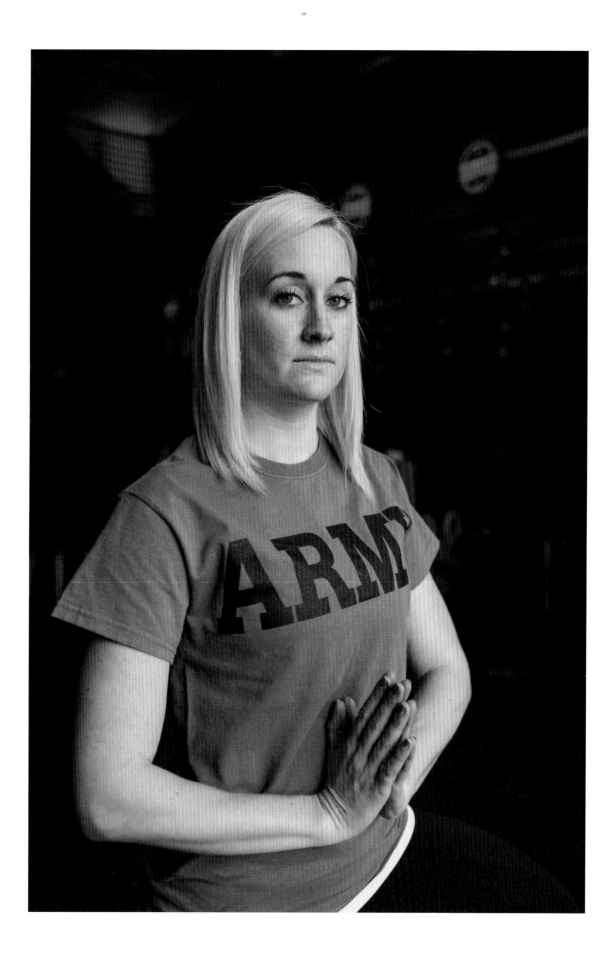

When I was six years old, I was confronted by a Neo-Nazi while at Camp Valley Chai, a Jewish day camp in Granada Hills, California.

Josh Stepakoff

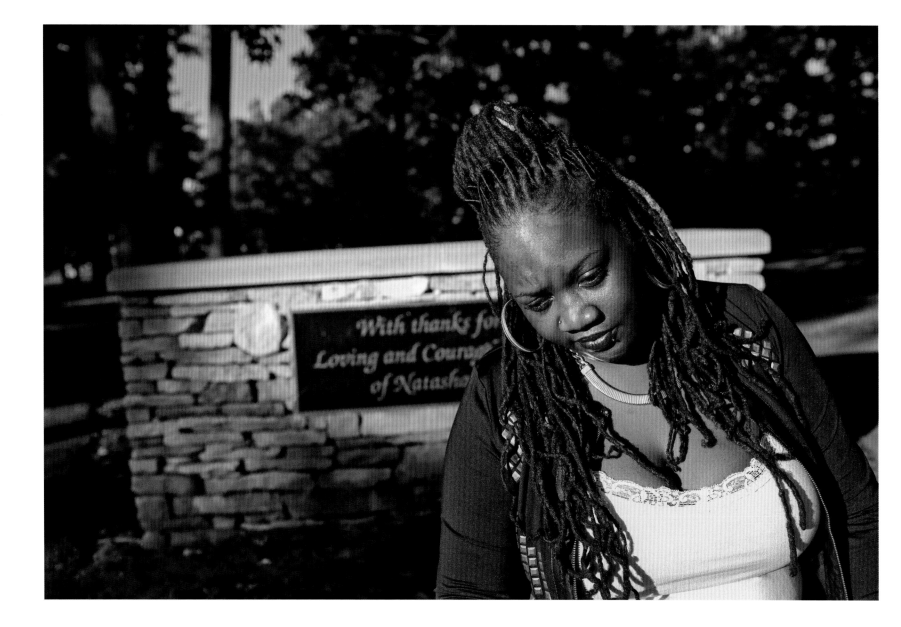

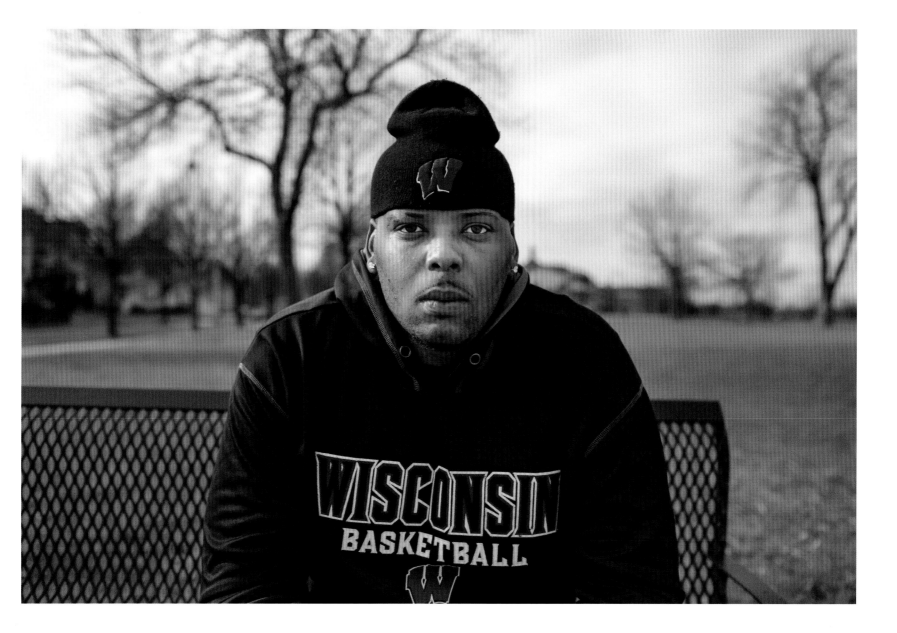

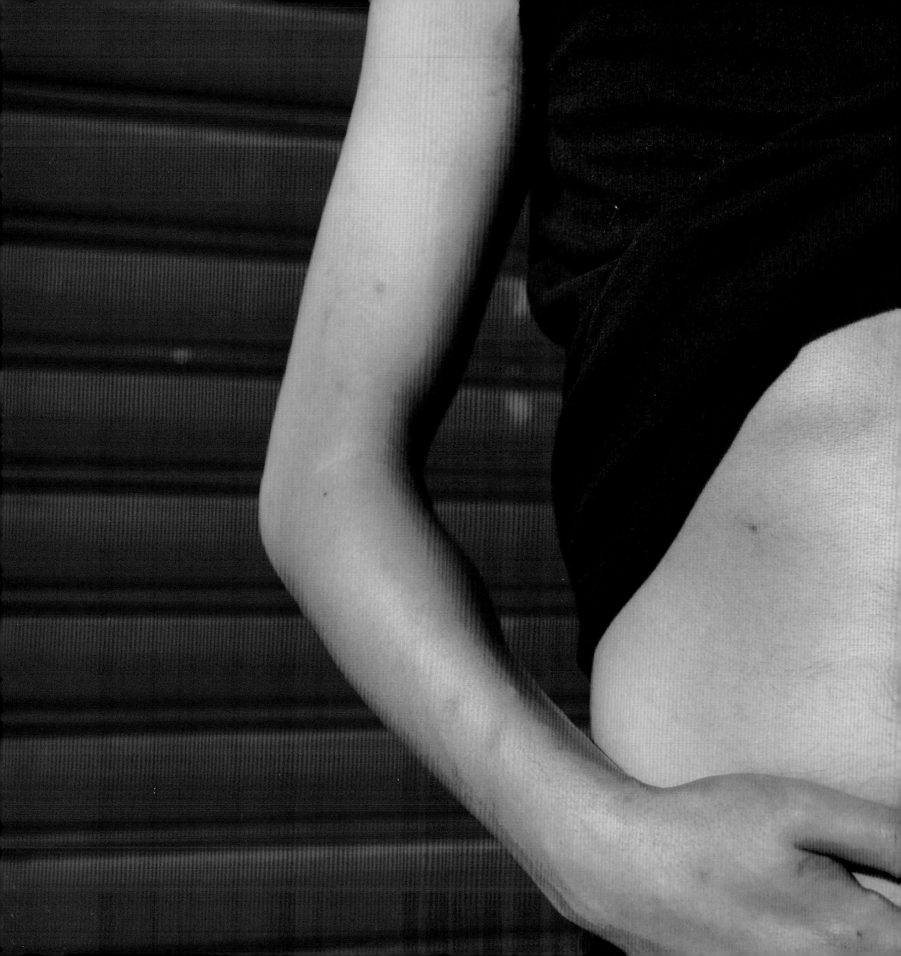

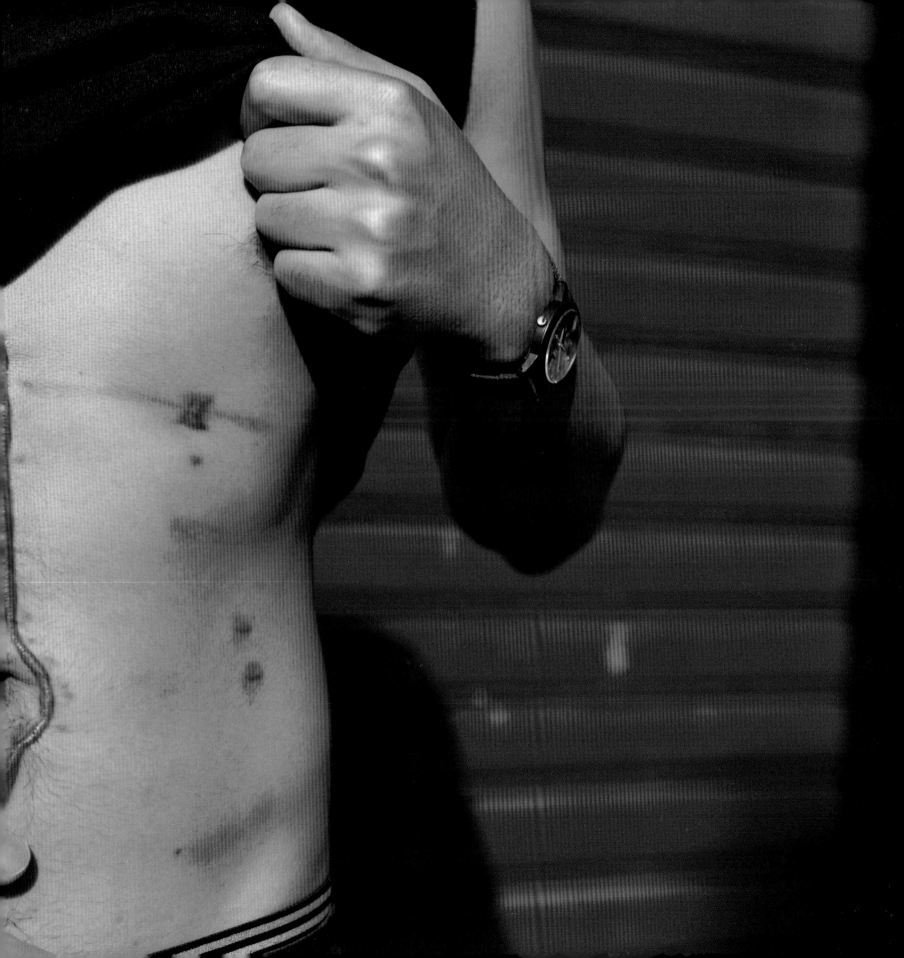

In 2013, there were 84,258 nonfatal injuries caused by firearms.

The Center for Disease Control and Prevention

AFTERWORD

The first thing I noticed was the look of intense panic in her eyes. Then she started to cry. My team descended upon her immediately and, in a flurry of activity, we worked rapidly to save her life. "BP is 80 over 60," shouted my nurse. "Activate the MTP, she needs blood," I remember responding. "We can't get access, we'll need a central line," yelled my resident. I could sense that the level of panic was higher than the standard traumas we were accustomed to, day and night, at the Ryder Trauma Center—one of the busiest trauma centers in the country. My patient was now completely naked and vulnerable while we examined her for more wounds throughout her body. Then I remember her pulling me close, desperately. She had something she needed to tell me. "Please don't let my baby die." Tiffany Davis was 27 years old and eight months pregnant when she was shot multiple times during a drive-by shooting in a poor neighborhood of Miami. Her unborn daughter, Skyla, was the youngest survivor of gun violence in the United States. Skyla was shot through her left arm while still in utero. Tiffany sustained injuries to her small bowel and brain. The intended victim of the drive-by shooting was killed. He was 18 years old.

The year 2015 marks the first time that the number of Americans injured by gun violence surpassed injuries caused by motor vehicle collisions. The United States has the highest rate of gun violence of any other high-income country in the world. It also has the perfect combination of easy access to weapons, increasing poverty, economic inequality, and injustice in a country that sells dreams of wealth, consumption, and libertarian principles. As trauma surgeons, we are stimulated and challenged by the patients that come in only moments away from death. These are the ones we need to resuscitate quickly and operate on even faster to stop the bleeding, normalize the physiology, and shun death, at least for another day. These are our surgical victories. But every victory is a story of human tragedy. Every damaged blood vessel or organ belongs to a human being. That human being belongs to a family, a community, and a society. They each have a name, a life, and a series of experiences and events that led up to the worst day of their lives. They are loved. Someone loves every patient who is shot. And each surgical victory is the end-result of a societal failure.

I remember every case. I remember the murder/suicide of the recently separated husband who shot his wife before turning the gun on himself. I remember the elderly woman who was wheelchair-bound who was shot by a volley of stray bullets while in her living room. I remember the three-year-old who accidentally shot himself in the head when looking for his iPad at home. I remember the 24-year-old man who was shot after warning an erratic driver to be mindful of the children in the neighborhood, playing near the road.

My team remembers the 10-year-old boy who was shot by a stray bullet as he retrieved a basketball from his front lawn. We remember exactly what our patients look like when they come to us. It's the same panicked look of the fear of dying after the realization sets in that they have been shot. Sometimes our patients even tell us they are dying, which in medicine, is an incredibly accurate and ominous sign. Most often, our patients shed tears of relief when we tell them that they will survive, that they will be OK. Men, women, young and old, it doesn't matter. They let the tears flow, predictably, shamelessly, and naturally, demonstrating that we are all human beings, thankful to live another day. The worst part of the job is telling the family that there was no surgical victory this time. Death beat us, and their loved one has died. The most unnatural thing in the world, ever, is to tell the parents that their child has died. Especially when that death was preventable, since it was due to gun violence.

Skyla is alive today, as is her mother. Their survival was a victory. But it is an empty victory if we cannot keep Skyla, and so many more, safe from further harm. It is a hollow victory indeed if we fail to create a society that allows each one of us to develop our human potential, free from injury, harm, and premature death, for the betterment of all.

<div align="right">

Tanya Liv Zakrison, M.D., M.P.H., F.A.C.S., F.R.C.S.C.
University of Miami

</div>

SHOT 101

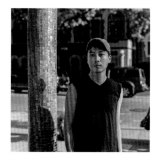

Antonius Wiriadjaja was struck by a random bullet as he walked down a crowded Brooklyn street. The intended target was the ex-girlfriend of the shooter.

Brooklyn, New York, 2013; pgs. 62, 91, 92

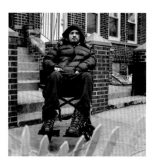

Only 14 when he was shot while "trying to live the fast life," Luis Lopez is now a speaker for Wheelchairs Against Guns.

Brooklyn, New York, 1990s; pg. 24

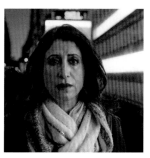

Around midnight Raven Starke was walking to her corner store when she was shot.

Manhattan, New York, 2011; pgs. 27, 28, 74

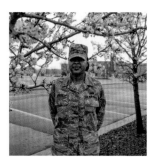

Moni Gravelly was attending the Batman movie premiere when she was shot. She was one of more than 50 wounded in the attack. A friend who was sitting next to her was killed.

Aurora, Colorado, 2012; pgs. 65, 82

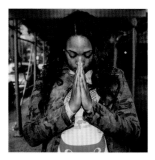

Early one evening Sahar Khoshakhlagh was strolling through Times Square with her cousin when she was hit. A police officer was pursuing someone else when he fired.

Manhattan, New York, 2013; pg. 2

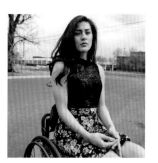

Standing with a group of friends outside of her high school, Karina Sartiaguin became the unintended victim of a drive-by shooting fueled by gang revenge. She was 16.

Aurora, Colorado, 2010; pg. 23

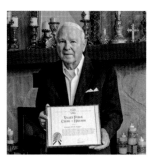

Colonel Bill Badger was a hero and an Army veteran of 30 years. He was shot in the head at a public meeting organized by Gabby Giffords. Badger managed to take the shooter down.

Tucson, Arizona, 2011; pg. 29

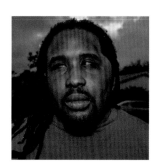

Rayvn Richards was a teenager when he was blinded by a "friend." Richards has since graduated from college and is now a motivational speaker on gun violence.

Miami, Florida, 2002; pgs. 7, 8

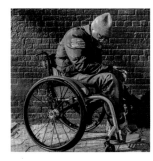

A young life lived on the streets was changed forever when Kareem Nelson was paralyzed by a bullet at 21. Nelson is now the director of Wheelchairs Against Guns, an advocacy group that speaks to New York City teens about gun violence.

Baltimore, Maryland, 1995; pg. 23

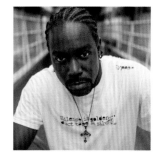

Picking up a take-out order, Jewelz Hinnant was injured in a restaurant by another patron. Earlier that day the other customer had argued with the owner and had come back to kill her, shooting Hinnant in the process. The police thought he was the perpetrator until the restaurant owner, with her last words, asked, "How is my customer?"

Miami, Florida, 2006; pg. 31

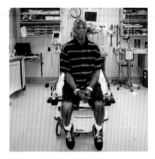

Walking down the street, Calvin Price was approached by two boys on a bicycle. The one riding on the handlebars jumped off and started firing. Price was shot 11 times.

Miami, Florida, 2013; pg. 32

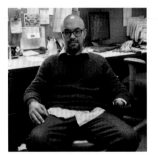

Shot on the street when he was 12, Agustin Lizama now works for Homeboy Industries.

Los Angeles, California, 1990s; pg. 81

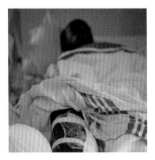

Octavius Owens was a teenager when he was shot in the leg.

Miami, Florida, 2014

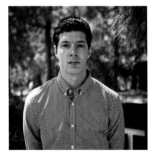

Josh Stepakoff was at Camp Valley Chai, a Jewish day camp, when he was shot by a neo-Nazi. He was six years old. Five people were shot, including three children. Afterward, the gunman killed a mail carrier.

Granada Hills, California, 1999; pg. 88

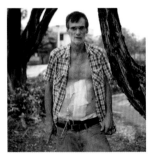

At a small hotel in Miami, Roger Tucker was assaulted by a jealous and deranged co-worker.

Miami, Florida, 2014

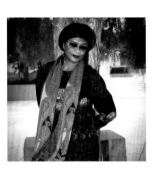

Homeless when struck by a bullet, Lorraine Morland has lost two sons to gun violence.

Los Angeles, California, 1980s

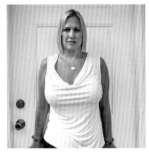

Separated from her military husband, Kate Ranta was ambushed as she returned home. Her husband chased her to the door and began firing as Ranta and her father tried to close it. They were both shot. Her young child, who was also there, escaped physical injury.

Coral Springs, Florida, 2012; pg. 40

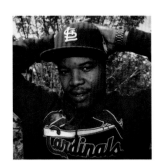

Sitting in a car with a friend, Breon Grant was hit by 11 bullets that were fired from a passing car. Initially, he was totally paralyzed. Grant also lost a lung.

St. Louis, Missouri, 2012; pg. 76

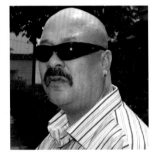

Gus Mojica was attacked by rival gang members and shot in both legs; one was amputated. He works for Homeboy Industries.

Los Angeles, California, 2000; pg. 47

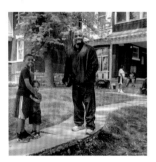

After cashing his paycheck on a street called "Dead Man's Alley," Albert Randle was shot point blank in the stomach with a shotgun. Since the shooting, he has suffered two strokes and is now on a heart transplant list.

St. Louis, Missouri, 1987; pg. 10

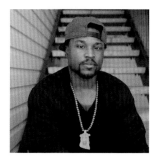

James Royal was lying on his couch watching TV when a bullet that came through the building's exterior wall injured him. Initially, the police handcuffed him because they did not believe his story.

Indianapolis, Indiana, 2014; pg. 31

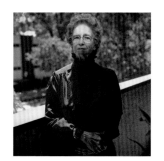

After stating that he planned to kill her, Marlys Nunneri was shot through the heart by her husband of 41 years.

Canoga Park, California, 1999; pgs. 79, 80

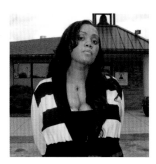

Ambushed by her ex-husband, Shirley Justice was shot as she got her daughters from nursery school. Her ex-husband used two guns and struck her 14 times. The former military man was released on $25,000 bail.

Indianapolis, Indiana, 2014; pg. 72

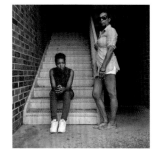

Demetria Logan was sitting on her bed and talking to her mother when a random bullet flew through the window. Logan was a high school senior at the time.

Newport News, Virginia, 2014

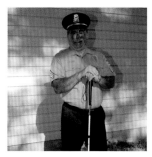

Police sergeant Jon Brough was hit in the face by a wanted man who had just murdered two people. The sergeant's face shield malfunctioned and he was blinded by the bullet.

Belleville, Illinois, 2006; pg. 36

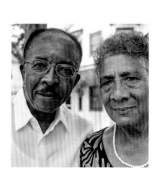

When gunfire erupted on an otherwise quiet street, Pastor Turner was struck by a bullet that penetrated the wall of his home office while he was writing a sermon.

Newport News, Virginia, 2014; pgs. 41, 42

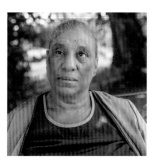

Attacked in her home by her estranged husband, Jesuita Tabor was blinded in the incident. A guidance counselor and former teacher, she said that her husband hadn't previously displayed any sign of domestic violence.

Los Angeles, California, 1986; pg. 44

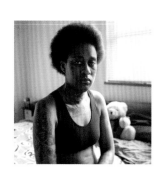

Shanessa Pittman was shot by her sister's boyfriend. A year later, she was shot again, in the face and hand; this time it was by his friends who wanted to stop her from testifying against him.

Newport News, Virginia, 2014 and 2015; pg. 55

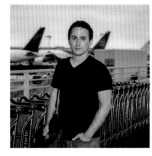

Passing through an airport checkpoint, Brian Ludmer was hit by a man who was shooting at airport security officers. One person was killed and several others were injured.

Los Angeles International Airport, California, 2013; pg. 31

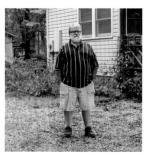

A mentally ill neighbor attacked Kenny Vaughn in his driveway. He was shot 20 times.

Rougemont, North Carolina, 1995; pg. 9, 94

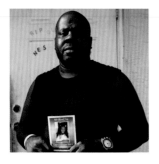

Pastor Gillum lost his son when they were both shot. The two were trying to break up a fight outside of their home.

Miami, Florida, 2012; pg. 13

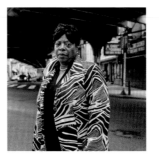

A former prostitute and drug addict, Annette Byrd was shot by a client who then killed the man whose room she had rented for work. She was shot three times and pretended to be dead until the perpetrator left the room. She then ran out to the street, naked and screaming for help. Byrd is now a counselor.

Philadelphia, Pennsylvania, 1985; pgs. 14, 38

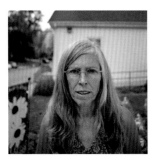

Attempting to stop a fight outside of a nightclub, Robert Bozeman was shot in the head.

Miami, Florida, 2005

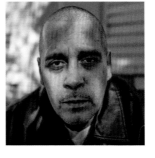

Detectives were initially chasing another man into a building when they saw Tony Rigual, a former drug dealer walking down the street. Hit by a black talon bullet in the ensuing shootout, it took two shifts of doctors to stabilize him due to the extensive damage. Rigual served 13 years in prison, and is now an IT specialist and motivational speaker in Connecticut.

Bridgeport, Connecticut, 1995; pg. 77

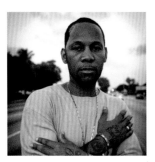

A stranger walked in to a meeting at the Landenberg Methodist Church and starting firing, shooting Starr B.

Landenberg, Pennsylvania, 1991; pg. 56

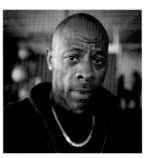

Reggie Talbert was accidently shot by his girlfriend. She was fooling around with his shotgun that she thought was empty, unaware that a bullet was still in the chamber.

Boston, Massachusetts, 1986; pg. 76

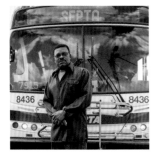

Joe Wilson has been shot in three separate incidents: twice while driving his bus and once while standing on a street corner talking to a friend. His son was killed by gun violence.

Philadelphia, Pennsylvania, 1987, 1984, and 1982; pg. 18

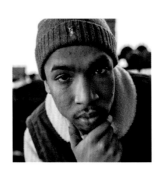

While bringing some toys to his son Tyrice Anthony was ambushed in front of his girlfriend's home.

Dorchester, Massachusetts, 2012

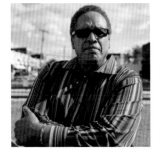

Coming to the aid of a friend in a barroom fight, Joel Seay was the unintended recipient of a bullet. His daughter is a gun violence survivor. His teenage son was shot and killed on their porch in front of him in 2011.

Philadelphia, Pennsylvania, 1982

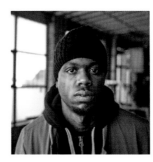

Eric Flores was struck by a bullet while he was riding his bicycle.

Boston, Massachusetts, 2007

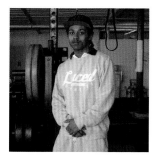

Fifteen-year-old Dario Baxter was shot on a city street.

Boston, Massachusetts, 2012

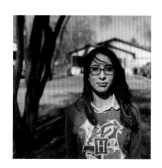

Sitting in her sister's home and watching TV, Estefania DeLeon was hit on the nose. Intended for the neighbor's house, the bullet pierced her sister's living room wall.

Dallas, Texas, 2009

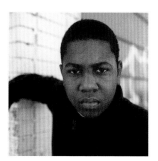

Watching the local West Indian Parade, Tyrek Marquez was hit when feuding gangs began firing. He was seven years old.

New Haven, Connecticut, 2008

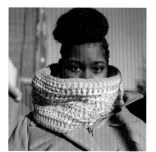

At six years old, Aniyah Halsey was in her family's car when a group of young men opened fire on the street. A bullet hit her in the leg.

Brooklyn, New York, 2006; pg. 59

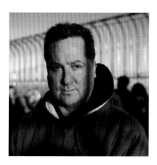

On a visit to the Empire State Building, Matt Gross was shot in the head by a man outraged at the Palestinian-Israeli conflict. His best friend and band mate was killed.

Manhattan, New York, 1997; pg. 61

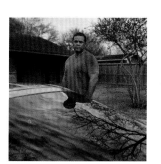

Creig Artis refused to pay a $1,000 balance on a $4,500 repair bill for his Corvette, which had not been properly fixed. Following him from the shop, the mechanic's father punched Artis in the face and then the mechanic fired six shots, hitting him once in the leg. They then drove off with his car.

Baytown, Texas, 2013; pg. 19

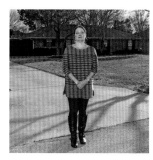

Kathleen Storm was at home when her husband shot her in the head.

Ovilla, Texas, 2007; pg. 9

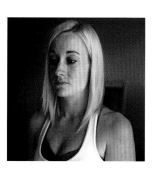

During the Fort Hood shootings Dayna Roscoe was wounded by a crazed psychiatrist who killed 14 people and injured 32 in the massacre. An Army sergeant and Purple Heart recipient, Roscoe was shot three times when the gunman found her hiding behind a table.

Fort Hood, Texas, 2009; pgs. 78, 84

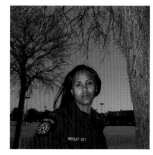

Dallas deputy sheriff Shyrica Wesley was in a Walmart parking lot when her husband shot her and then killed himself.

Garland, Texas, 2007; pg. 4

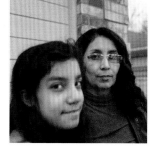

Shot by her husband in front of her children, Damary Espinoza was blinded in one eye from the attack.

Houston, Texas, 2010

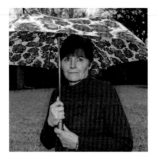

A shotgun blast at point-blank range wounded Laura White in the stomach. It was fired by her soon-to-be ex-husband, a former Marine and police officer. He then threatened to kill himself, but could not pull the trigger. His wife lay on the floor and begged him to call 911 for a half hour. When help finally arrived, she had started to bleed out and was given a 1% chance of survival.

Houston, Texas, 2009; pg. 59

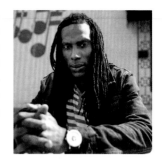

Prince Bass-Ajetunmosi went to his uncle's aid during a fight when someone came from behind to rob him and shot him three times.

Kansas City, Missouri, 2013; pg. 68

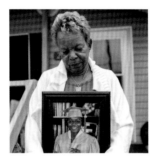

Social worker and domestic violence counselor Elizabeth Mahoney was shot three times in the face by her estranged husband. Her 18-year-old daughter was killed during the attack.

Violet, Louisiana, 2009; pg. 14

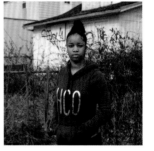

Seventeen-year-old Chloe Johnson was talking with friends on the street when a stray bullet hit her in the head.

Kansas City, Missouri, 2013; pgs. 10, 85, 86

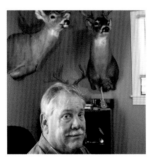

Cajun councilman Phillip Gouaux was wounded in the throat by his former son-in-law during a shooting spree that killed Gouaux's wife and paralyzed one of his daughters. In total, three people were killed and three were injured before the gunman shot himself.

Lockport, Louisiana, 2013; pgs. 3, 11, 12

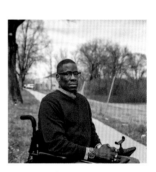

A jealous member of his high school basketball team shot Tyrone Flowers as he was getting off a bus. Flowers is now a lawyer and the founder of Higher M-Pact.

Kansas City, Missouri, 1988; pg. 23

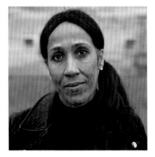

Activist, reporter, and blogger Deborah Cotton is among the survivors of the Mother's Day Second Line shooting, which she was covering for her job. Cotton has undergone almost 30 surgeries to repair the damage.

New Orleans, Louisiana, 2013; pg. 56

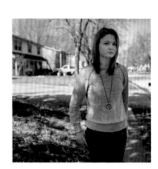

Ally Howe was visiting a friend when she was shot in the head. Unaware it was loaded, Howe's friend was fooling around with a gun that her father had left on the table when it went off.

Lee's Summit, Missouri, 2012; pg. 59

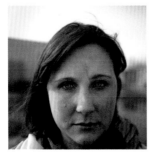

Shot through the forehead at point-blank range, Sara Cusimano was sitting in her mother's car when a carjacker stole it. He drove to a field and raped her, and then made her kneel down and count to ten before attempting to execute her.

Kenner, Louisiana, 1994; pgs. 45, 46

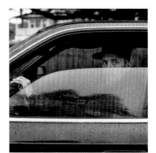

As he sat in his car talking with his ex-girlfriend, Ryan Carney was hit in the hand by a bullet. He lost one finger and is crippled in two others.

Atlantic City, New Jersey, 2014; pgs. xiv, 19

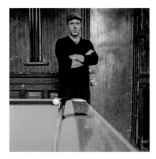

After leaving a bar, Kenny McLaughlin was accosted and mugged by a group of teens. Trying to get back to the bar for help, he was then shot by one of them who thought McLaughlin was following him.

Brooklyn, New York, 1996; pg. 30

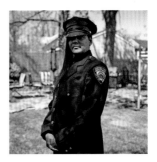

Janine Howard, a corrections officer, was accosted at home by her husband, a captain with the corrections department. He shot her after she told him that their marriage was over.

Long Island, New York, 2013; pgs. 15, 16, 64

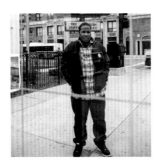

Walking in a neighborhood known for its drug activity, 19-year-old Tyrone Curry was hit in the leg with a 12-gauge shotgun. The injury never healed properly and still gets infected. Four years later, Curry was hit in the same leg. He was one of three guys shot in front of a McDonalds by a teen gang member.

Chicago, Illinois, 1989 and 1993; pgs. 20, 51

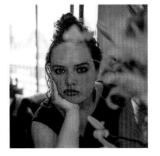

Blues singer and activist Courtney Weaver was shot in the face by her boyfriend. He received four years for her attempted murder and seven years for firing at a police officer who had arrived on the scene. He is eligible for unconditional parole in 2019.

Arcadia, California, 2010; photographed at home in Seattle, Washington

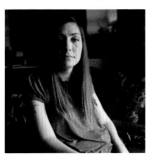

Stopped at a red light, Mariam Pare was struck in the neck when a bullet ripped through the seat of the car she was driving. Left a quadriplegic, she became a member of the Mouth and Foot Painting Association. Pare credits art for getting her through the ordeal.

Richmond, Virginia; 1995; pgs. 57, 58; photographed at home in Naperville, Illinois

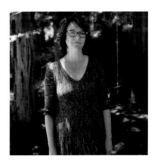

At eight years old Liz Hjelmseth was injured by her then 16-year-old brother, who was apparently angry about her cat and shot her. The family deemed it an accident and no charges were brought.

Manhattan, Montana, 1972; pgs. 32, 50; photographed at home in Bellingham, Washington

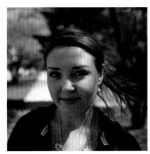

Fifteen-year-old Janelle Sippel was shot in the groin by her 17-year-old boyfriend. He was playing around with his gun and it went off. She cannot have children because of the injury.

Joliet, Illinois, 2008

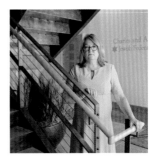

While at her office at the Jewish Federation of Greater Seattle Cheryl Stumbo was shot five times. The hate crime killed one woman and injured five others. The shooter screamed, "I'm a Muslim American; I'm angry at Israel."

Seattle, Washington, 2006; pg. 32

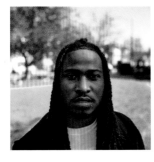

After an argument with a 14-year-old at a party, Ondelee Perteet was shot in the face when the boy returned with a gun. Perteet's mother had to quit her job to care for him.

Chicago, Illinois, 2009; pg. 24

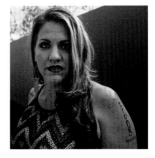

Holding the hand of her two-year-old son, Alexis Star Caldwell was hit in the abdomen with a bullet fired by her roommate's boyfriend. He had already strangled her roommate on a weekend getaway and shot Star because she was the only one who knew about their trip.

Salt Lake City, Utah, 1997; photographed in Seattle, Washington

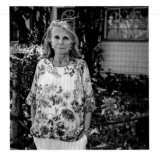

Former Berkeley Barb reporter Gabrielle Schang fled from a slow-moving van after being robbed and raped on a quiet street. She was able to open the door and roll out of the van before he shot her in the back.

Berkeley, California, 1973; pg. 66

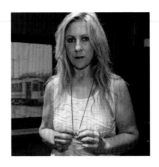

In the Trolley Square massacre, Carolyn Tuft was shot three times at close range. She had been shopping for Valentine's Day cards. Five people were killed, including her 15-year-old daughter. The 18-year-old shooter used a pistol grip shotgun, a firearm that is illegal to own under the age of 21 in Utah.

Salt Lake City, Utah, 2012; pg. 13

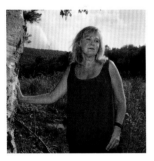

Sitting in a car at an intersection, Caheri Gutierrez was shot in the face by an unknown assailant. Gutierrez was 18 years old and an aspiring model. The shooting is believed to have been a gang initiation.

Oakland, California, 2008

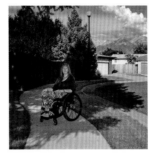

A man recently released from prison grabbed LaDawn Prue in front of her house and dragged her to his car before shooting her in the neck. Prue attempted to get out of the vehicle and was shot in the lower back, paralyzing her.

Sandy, Utah, 1982; pg. 23

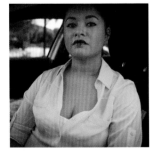

Mary Jo McLaine was hit in the back during a family outing near her home in the Poconos. A man living in the area had followed their Jeep, telling them to get off his property (actually it wasn't). He began firing as they attempted to drive away.

Noxen, Pennsylvania, 2012

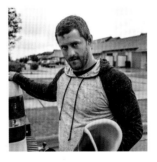

James Armstrong lost the lower part of his leg after talking to a rowdy guest at a birthday party. The guest, a former military man, returned to the party, placed a shotgun on Armstrong's calf and fired. He then turned the gun on Armstrong's friend, killing him. When he put the gun to the head of a second friend, it jammed.

Bozeman, Montana, 2013; pg. 50

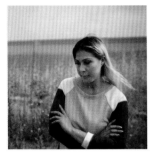

After leaving her shift at a Holiday Inn around 11:00 p.m., Cori Romero got in her car to drive home. Headed for the freeway, she stopped at a red light. In the next second Romero was shot in the neck. The shooter then drove off.

Fort Collins, Colorado, 2015; pgs. 19, 47, 48

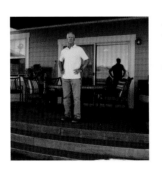

A 14-year-old who was failing French class, planned to murder his French teacher. He encountered a substitute teacher in the classroom and shot her in the face, killing her. While fleeing the high school he ran into vice-principal John Moffatt and shot him in the abdomen. His next shot, aimed at John's head did not fire.

Lewiston, Montana, 1986; photographed in Missoula, Montana

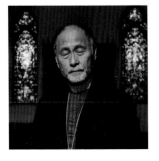

During his freshman year at the University of Washington, Scott Hayashi worked part-time in a record store. Three robbers entered the store and one of them shouted something. As he turned to the man, the thief fired, hitting Hayashi in the abdomen. He is now the Episcopal Bishop of Utah.

Tacoma, Washington, 1972; pg. 22; photographed in St. Mark's Episcopal Cathedral, Salt Lake City, Utah

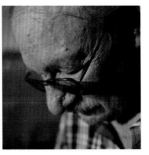

After losing a court judgment to Dave McDunn and his wife, their former landlady broke into their home and ambushed the retired firefighter upon his arrival. Though he was shot three times, McDunn managed to subdue her. Police found the house filled with newspaper and two gallons of gasoline. The landlady planned to kill the couple and then set the house on fire.

Bozeman, Montana, 2012; pg. 37

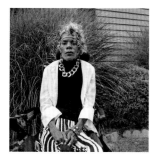

Margaret Long was paralyzed by her boyfriend's father who had seen them arguing after a house party. He testified that he was protecting his son from Margaret and was found not guilty.

Cincinnati, Ohio, 1991; pg. 69

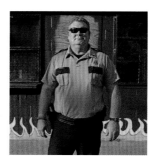

While working a drug bust, police sergeant Greg Meagher was shot in the face by the drug dealer.

Augusta, Georgia, 2004; pg. 19

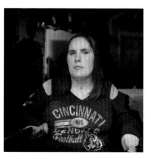

Ambushed by her ex-husband in the lobby of her office building Alisha Waters is now a quadriplegic. Although he had been cyber-bullying her for months, the DA's office refused to grant Waters an order of protection because her ex had not been physically abusive. She now receives full-time care from her parents.

Florence, Kentucky, 2013; pgs. 77, 78

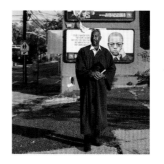

Minister Ellis was hit during an armed robbery at a gas station. The community activist now teaches drama and is a Little League coach in New Jersey.

Atlanta, Georgia, 1997; pg. 75; photographed in Newark, New Jersey

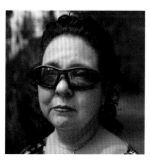

After telling Thérèse D'Encarnacão, "If I can't have you, no one can," her husband shot her in the head and then killed himself. She is a former nurse and a domestic violence activist.

Charleston, South Carolina, 2010

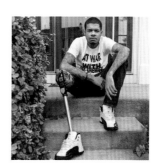

College student Chris Harris was struck four times in his car when a neighborhood acquaintance was trying to rob him. Harris lost a leg from the shooting.

New Castle, Delaware, 2015; pgs. 49, 70, 75

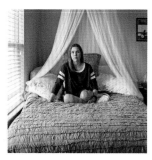

Martha Childress, a student at the University of South Carolina, was paralyzed when a gang member fired his gun as she and her friends were waiting for a taxi.

Columbia, South Carolina, 2013; pg. 32

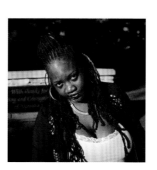

While sitting in a schoolyard with her brother and two friends, Natasha Aeriel was shot in the head and raped. Her three companions were executed. A gang initiation may have been the motive for the six young men involved. Aeriel received her master's degree in 2016.

Newark, New Jersey, 2007; pgs. 63, 89

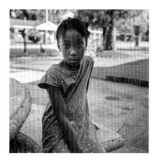

Eight-year-old Taniya Cheatham was shot by another third-grader in their classroom. The boy had found the gun in his home and brought it to school.

Augusta, Georgia, 2015; pg. 43

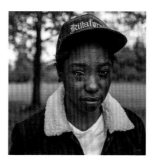

Aisha Dindy Adams was shot in the chest and then in the head by a teenage acquaintance who owed her 40 dollars. Adams lost her right eye. He was sentenced to five years in jail.

Newark, Delaware, 2012; pg. 59

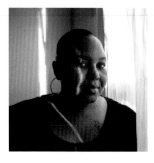

After an argument in a parking lot with a convicted felon, Sheri Seay-Cobb was shot in the chest. Her boyfriend was killed in the altercation.

Corapolis, Pennsylvania, 2001; pg. 73

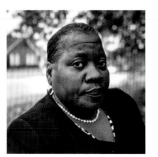

Three-year-old Phyllis Abdulla was shot by her father in the family kitchen; he was trying to shoot her grandmother. The room was filled with family members of all ages.

Memphis, Tennessee, 1957

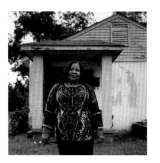

The jealous boyfriend of Donzahelia Johnson shot her once and then chased her down the street. The 28 year old then pointed the gun at her head and tried to fire again, but it failed to go off. Johnson was 16 years old at the time of the shooting.

Memphis, Tennessee, 1980

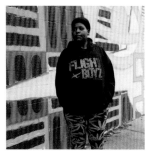

On Halloween, a group of teens opened fire on Lucie Slater and her family and she was shot. The teens had a conflict with her cousin.

Memphis, Tennessee, 2010

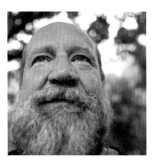

Jeff Droke was shot eight times, including twice in the head. He had testified against a couple who then hired someone to kill him. When the shooter fled to his car, Droke fired at him with his licensed handgun. He credits having a gun with his survival.

Memphis, Tennessee, 2003; pgs. 34, 94

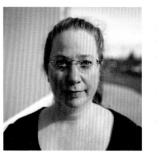

During a salsa class, Steph Latusick was struck by a gunman who walked into the class of 25 women, turned off the lights, and began shooting. Three women were killed and nine were injured. It was classified as a hate crime because the shooter had written a lengthy manifesto about his plan and his rage against women. He killed himself after firing on the women in the gym.

Pittsburgh, Pennsylvania, 2009; pg. 67

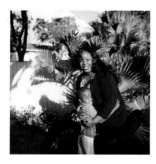

Donning guerrilla fatigues and camouflage to complete his "mission," the former Army man ambushed Keiba Young in the parking lot of their apartment complex. She was his fiancée and the mother of his son. He had never acted violently toward her prior to this incident.

Miami Lakes, Florida, 1999

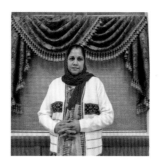

Jasbir Dulai was cooking for the congregation at a Sikh temple when a white supremacist and former Army veteran entered the temple and opened fire. Six people were killed and four were injured. The supremacist killed himself after shooting at a police officer on the scene.

Milwaukee, Wisconsin, 2012; pgs. 31, 52

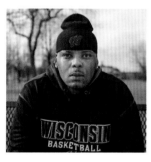

Megan Hobson was shot through the pelvis with an AK-47. Stopping to drop someone off, the car she was riding in was besieged by a hail of bullets. She lay on top of a toddler who was also in the car to protect the child. Hobson now walks with a limp. A gang initiation is believed to be the motive.

Miami Gardens, Florida, 2012; pg. 35

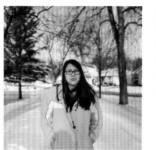

As she ran toward her house, Native American Karissa Dogeagle was shot three times in the back by her abusive boyfriend. She was 22. He killed three people during the shooting spree, including Dogeagle's best friend. The boyfriend then turned the gun on himself.

Sisseton, South Dakota, 2014; pgs. 60, 94

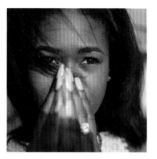

The first time Isiah Johnson was shot he was hit three times, once in the chest. A group of strangers had pulled up to his car and started firing. The second incident resulted from a dispute between two groups at a club. Johnson was leaving the club and saw some of the arguing men in a car. Telling his date to go back inside, he started to drive away and was shot in the arm.

Milwaukee, Wisconsin, 2014 and 2015; pg. 90

Manhattan, Brooklyn, Long Island,
Hartford, Bridgeport, Newark, At
Newport News, Beaumont, Philad
New Castle, Poconos, Cincinnati
Charleston, Columbia, Augusta,
New Orleans, Indianapolis, Chica
Kansas City, Joliet, Dallas, Houst
Fort Collins, Tucson, Salt Lake C
Missoula, Seattle, Berkeley, Oak
Los Angeles, Canoga Park, Atlant
Bellingham, Memphis, Pittsburgh

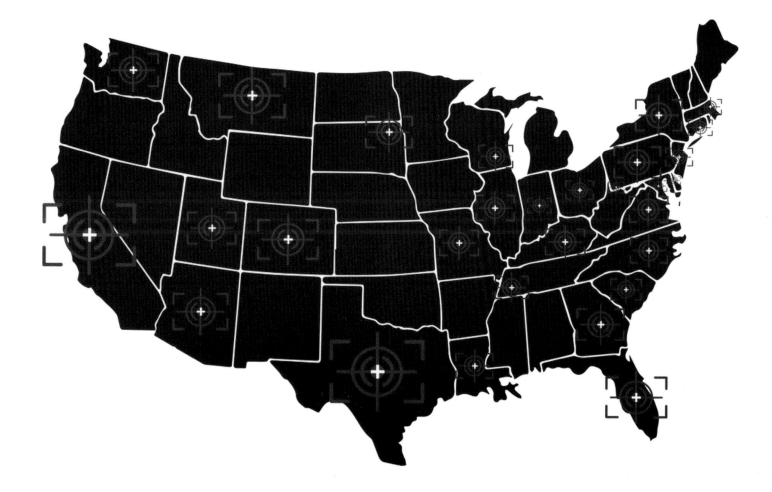

share your story at shotproject.org

INDEX

ACKNOWLEDGEMENTS

In memory of an American hero and survivor, Colonel Bill Badger.

My heartfelt thank you to all of the people who helped to make this book possible!

First and foremost to the 101 survivors who agreed to participate in the project.

Assistance in Locating Survivors:

Father Greg Boyle, Homeboy Industries, Los Angeles, California
Margot Bennet, Women Against Gun Violence, Los Angeles, California
Maisha Colter, Aid to Victims of Domestic Abuse, Houston, Texas
Maria Cheevers, Boston Police Department, Boston, Massachusetts
James Clark, Better Family Life, St. Louis, Missouri
Judy Donner, Indiana Coalition Against Domestic Violence, Indianapolis, Indiana
Lt. Blaise Dresser, Augusta Police Department, Augusta, Georgia
Jon Feinman, Inner City Weightlifting, Boston, Massachusetts
Angela Hale, Red Media Group, Dallas, Texas
Kayla Hicks, Virginians for Responsible Gun Laws
Movita Johnson-Harrell, The Charles Foundation, Philadelphia, Pennsylvania
Shane R. Kadlec Esq., Dallas, Texas
Lynn Kamin Esq., Dallas, Texas
Sarah Mervosh, Dallas News, Dallas, Texas
Chaz Molins, V.O.I.C.E., Newark, Delaware
Oliette Murry-Drobot, Family Safety Center, Memphis, Tennessee
Operation SNUG, New York, New York
Chris Patterson, One Northside, Chicago, Illinois
Father Michael Pfleger, St. Sabina's Church, Chicago, Illinois
RJT Foundation, Miami Florida
Amanda Sanchez, Dallas Mayor's Office, Dallas, Texas
Judy Schecter M.D. Jackson Memorial Hospital, Miami, Florida
Nakita Shavers, Dinerral Shavers Educational Fund, New Orleans, Louisiana

Harriet Sosson, Cape May, New Jersey
Mia Taylor, Family Safety Center, Memphis, Tennessee
Rosilyn Temple, Kansas City Mayor's Office, Kansas City, Missouri
Will Villota, New York, New York
Stacy Wesen, Witness Victim Program Director, Gallatin, Montana
Cathie Whittenburg, States United to Prevent Gun Violence
Carol Wofsey, St. Louis, Missouri
Tanya Zakrison M.D., Jackson Memorial Hospital, Miami, Florida

SHOT Book:

Craig Cohen

Deborah Hussey

Max Kozloff

Will Luckman

Blake Odgen

Krzysztof Poluchowicz

Anna and Tom Roma

Nikolai Shorr

Charles Traub

Tanya Zakrison, M.D.

Finally to my family: Charles, Marisa, Marc, Jack, Natalie, Nikolai, and Mom. Their constant support and love carried me throughout this journey.

SPECIAL THANKS TO ALL THE KICKSTARTER PATRONS

Lily Almog

Annette Louise Alvidres Grable

Richard Bamberger

Alice Beck Odette

Sherry Beck

Barbara Billows

Cynthia Bittenfield

Florence Buchanan

Martin Buhrz

Rosemary Camilleri

Cathy Caplan & Grahame Weinbren

Marguerite Casey Foundation

Barbara Cassidy

Bruce Chmieleski

Vincent Cianni

Toni Coburn

Charles Conic

Meade Cooper

E. Coughlin

Joyce Culver

Sara Cusimano

Michael Dalton

Angela Diaz M.D. MPH

Jeff Droke

Kartin Eismann

Camellia El Antably

Nina Emett

Phyllis Evans

Barbara Feldoff

Judith A. Flaherty

Mark & Coleen Flaherty

William J. Flaherty

Claudia Fruin M.D. FAAP, *bulletproofkidsutah.org*

Jessica A. Gonzalez

Munirih Gravelly

Howard Greenberg

Karen Grosskopf

Mark Hancock

Scott Hayashi

Christopher Hayes, *gvsfoundation.org*

Sarah Haynes

Paul Hertzmann

Liz Hjelmseth

Ann Marie Hobson

Jacqueline Hoffner

Reagan Holloway

Eileen Hoskin D.M.D.

Ray Huang

Shane Kadlec Esq.

Sardi Klein

Annie & Lewis Kostiner

David Kuik

Robin LaFloe

Karine Laval

Loretta Lee-Penington

Michelle Leftheris

Richard Leslie & Amy Young

Loren Lieb

Jonathan Lipkin

Brian Ludmer

Sarah Ludmer

Shane Lynch

Diane C. Madfes M.D.

Michael Malin

Micaela Martegani

Katharine Martinez

Shari & Bob Mayer

Kevin Mayle

Erin McLaine

John Mauch

Emma Murphy

Jack Oberhart

Cathy & John O'Rourke

Mariam Pare`

Kathy Park

Leva Patterson Pierce

Mark Peterson

Mike Petrizzi

Photo Shelter

Lyn & Pete Pierce

Darlene Pineda

Stephanie Polley

Deborah Postlewait

Joshua Radu

Abby Robinson

Anna & Tom Roma

Sheree Rust

Sharon Sapar Malenfant

Kim Sevene

Marisa Shorr & Marc Yaklofsky

Michael Shulan

Peter Soby

Kathleen Storm

Betty J. Stutler

Nina Stutler

Aidan Sullivan

Arlene Sypniewski

Steve Telepman

Aaron & Kasey Traub

Charles Traub

Daniel Traub

Janell Vircks

Cynthia Weglarz

Randy West

Cathie Whittenburg

Anna & Dennis Yaklofsky

Denise & Scott Yaklofsky

SHOT
101 Survivors of Gun Violence in America

Photographs © 2017 Kathy Shorr
Foreword © 2017 Max Kozloff
Afterword © 2017 Tanya Zakrison, M.D.

Published in the United States by powerHouse Books,
a division of powerHouse Cultural Entertainment, Inc.
37 Main Street, Brooklyn, NY 11201-1021
telephone 212.604.9074, fax 212.366.5247
e-mail: info@powerHouseBooks.com
website: www.powerHouseBooks.com

First edition, 2017

Library of Congress Control Number: 2016961969

Hardcover ISBN 978-1-57687-833-0 33614080206179

Printing and binding by Midas Printing, Inc., China

Photo editor Charles Traub

Creative direction & book design by Nikolai Shorr

10 9 8 7 6 5 4 3 2 1

Printed and bound in China

shotproject.org